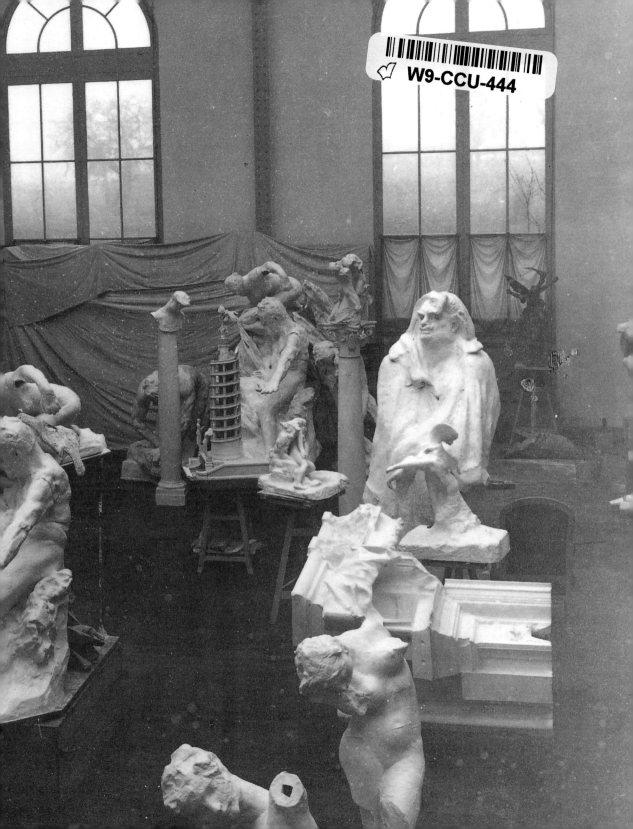

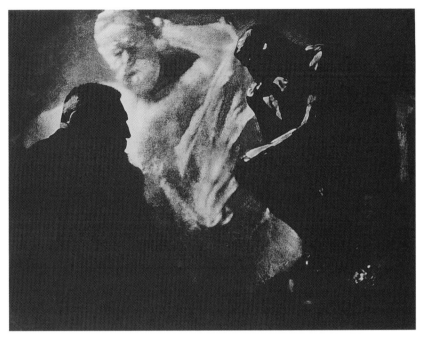

Edward Steichen: Rodin and the *Victor Hugo* Monument

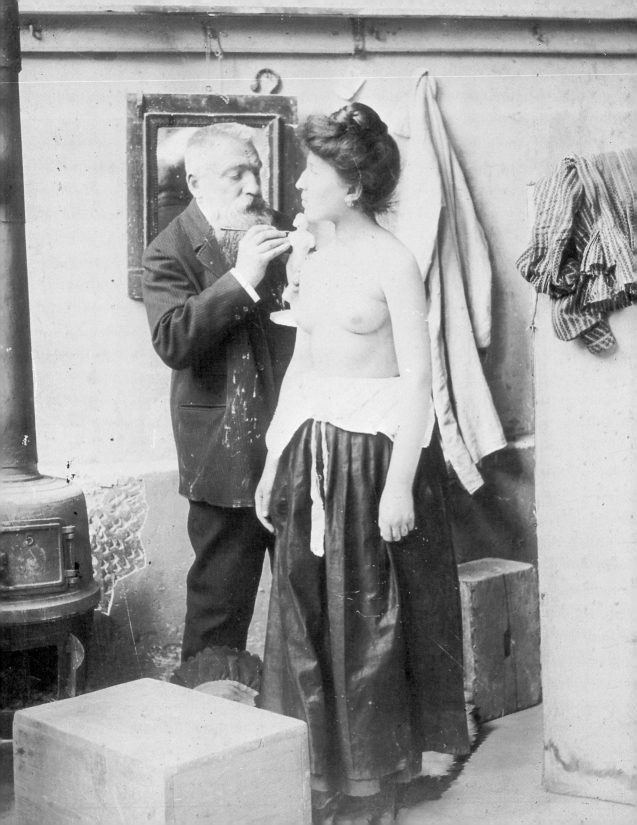

Auguste Rodin
Sculptures and Drawings

Text by
Gilles Néret

BARNES
&NOBLE
BOOKS
NEW YORK

FRONT COVER:
The Kiss (detail), 1886
Photo: AKG/Erich Lessing
ENDPAPERS:
Rodin's studio at Meudon, 1904/1905 © Photo: Bulloz
Rodin's funeral at Meudon, 1917
ILLUSTRATION PAGE 2:
Rodin with a model, around 1895
FRONT FLAP:
Auguste Rodin, around 1917
BACK COVER:
Auguste Rodin

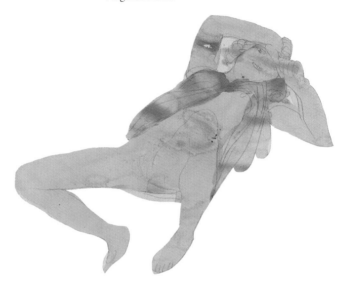

This edition published by Barnes & Noble, Inc.,
by arrangement with Benedikt Taschen Verlag GmbH
1995 Barnes & Noble Books

M 10 9 8 7 6 5 4 3 2

ISBN 1-56619-906-9

© 1994 Benedikt Taschen Verlag GmbH
Hohenzollernring 53, D–50672 Köln
Text and layout: Gilles Néret, Paris
English translation: Chris Miller, Oxford

Printed in Portugal

If truth is to die, my Balzac will be torn apart by the generations to come. If truth is imperishable, I predict that my statue will make its way in the world. This work which has been mocked, yet which could not be destroyed, is the culminating achievement of my entire life, the very lynchpin of my aesthetics. From the day on which I conceived it, I was a new man.

Auguste Rodin

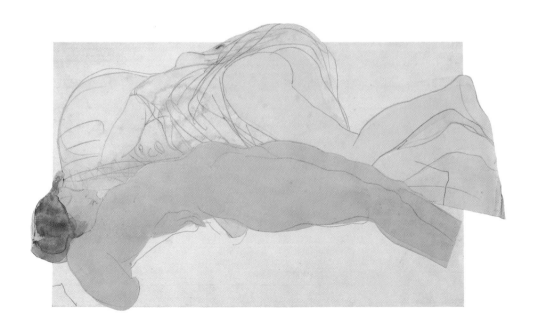

AUGUSTE RODIN
Marble Flesh, Bronze Passions

Rodin first exhibited his celebrated *Gates of Hell* in 1900. The Belle Epoque was at his height, and Art Nouveau was all the rage. By contrast, the promethean humanism of the *Gates of Hell* was at one with Freud's revelations about repressed sexuality and the unconscious. Monumental in scale, Rodin's masterpiece opened up a new world for art. What Van Gogh, Gauguin and Cézanne did for painting, Rodin did single-handed for sculpture.

Bridging the centuries in which it seemed that mind had been banished from sculpture, Rodin revived the tradition of the *cinquecento*. The inspiration that he drew from the Renaissance, and above all from Michelangelo, flows through his own work to fertilise the work of generations to come. In Michel Seuphor's words, "It was Rodin who, drawing them forth from their straitjacket of stone, imparted a further shudder of voluptousness to the 'Slaves' that Michelangelo had blocked out for the Tomb of Julius II." And Rodin himself stated: "The most remote antiquity is my habitat. I want to link the past to the present; to return to memory, judge it, and contrive to complete it. Symbols are the guidelines of humanity. They are no lies."

Truth and man's moral stature, these are Rodin's concerns. In his *Gates of Hell* the influences of Dante's *Inferno*, Ovid's *Metamorphoses* and Baudelaire's *Les Fleurs du Mal* come together in a creativity that owes everything to the "will to power" and the inventiveness hymned by Nietzsche. Rodin is a Michelangelo under the spell of Wagner... "Your door is not finished," came the reproach. "And the cathedrals of France: have they been completed?" came the sculptor's reply. Above all, the overwhelming *Gates of Hell*, with its convulsive outcrop of creatures less voluptuous than despairing, put an abrupt end to the bland academicism which had presided over sculpture for so long. True, certain of Rodin's predecessors, such as Houdon and Carpeaux, had wrested the clay into forms spiritual or psychological. But what is new in Rodin is the capacity to materialize the most confused and contradictory passions of introspective reality.

Between Rodin and sculpture it was love at first sight, total identification, for better for worse, a mystical marriage that he contracted in his seventeenth year. "For the first time," he said afterwards, "I saw separate pieces, arms, heads or feet, then I attempted the figure as a whole. Suddenly, I grasped what unity was... I was in ecstasy... For the first time, I saw sculptor's clay; I felt I was ascending into heaven."

During the day, Rodin earned his living as a plasterer, giving shape to the numerous monuments lavished by the architect Haussmann upon the new Paris he was building for Napoléon III. At night, Rodin worked on his own sculptures. Amongst these was the *The Man with the Broken Nose* (p. 20), inspired by Bibi, an old workman with the features of a Greek statue. The clay was split by the cold, but Rodin put it forward for the 1864 Salon nevertheless. It was, of course, rejected. Subsequently, one of his friends, to whom Rodin had generously given it, exhibited this work at the Ecole des Beaux-Arts, claiming that it was a superlative classical bust that he had discovered in a junk store. It caused a sensation. Whereupon the friend, triumphantly: "Well, let me tell you, the man who made that, a man named Rodin, failed this school's entrance exam three times, and this piece which you take for classical was rejected by the Salon!"

Rodin spent six years in Belgian exile. He collaborated first with Carrier-Belleuse, then with van Rasbourg, on decorative works which not only made him a living but matured his technique. Before settling in France, he visited Italy; Raphael, Michelangelo and the Sistine Chapel made an overwhelming impression on him. In 1906, he wrote to Bourdelle: "My liberation from academicism came through Michelangelo, who, by teaching me (through observation) rules diametrically opposed to those I had been taught (the school of Ingres), freed me... His mighty hand was held out to me. He was the bridge by which I crossed from one circle to the other..."

Now he was free to create his own masterpieces. No academic poses for Rodin; his models wandered freely around the studio. The lithe, sinewy contours of one such masterpiece, *The Age of Bronze* (p. 17), were as immediately admired in some quarters as suspected in others. The work was too perfect, and

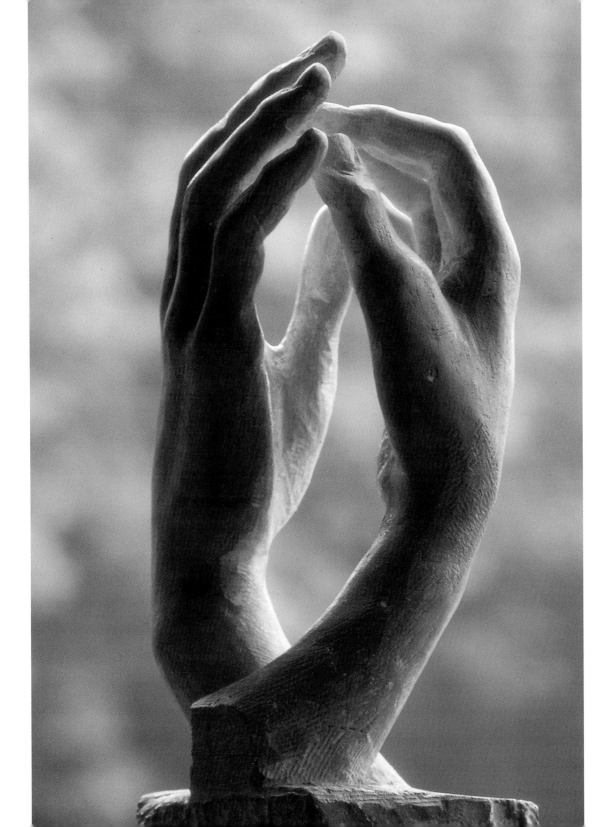

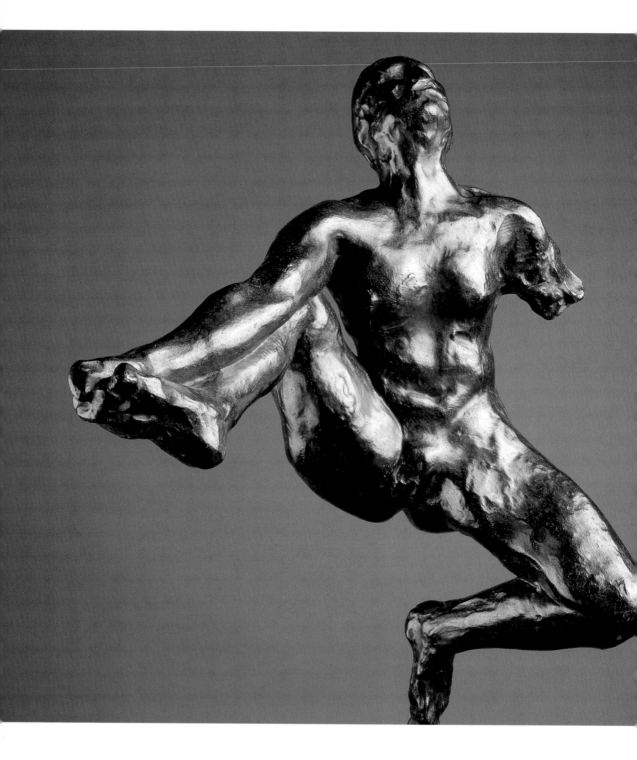

a scandal blew up as Rodin was accused of *surmoulage*, that is, of taking a mould directly from the body of the model, a practice common enough at the time, but degrading for a sculptor. To clear himself, Rodin had photographs taken that showed his nude model, a Belgian sapper named Auguste Neyt. His effort was wasted, as the committee of the Paris Salon did not so much as examine them. He was finally cleared of the suspicion only by the witness of some of the most eminent of his colleagues of the time, notably Carrier-Belleuse. With the proof of his innocence came a much enhanced reputation. He was no longer an "artist-mason", he was truly a sculptor.

In 1880 a petition signed by the artists who had defended him resulted in the Ministère des beaux-arts commissioning "Monsieur Rodin, artist-sculptor,... to execute, for the sum of eight thousand francs, the model of a decorative gate in bas-relief for the Musée des arts décoratifs representing the Divine Comedy of Dante." The French government also made available to him a studio of the requisite vast dimensions.

Rodin went to work at once, reading and re-reading the *Divine Comedy*, covering hundreds of pages of his sketch-book with studies, making dozens of maquettes, and painstakingly studying the examples of the genre: the gates of the Baptistry in Florence and in particular, Ghiberti's "Gates of Paradise". "Dante," Rodin declared at the time, "is not only a visionary and a writer, but a sculptor too..."

Paolo and Francesca (p.42), *Ugolino* and others of the damned are directly inspired by Dante, and *The Thinker* (p.34) represents the poet himself. But Rodin was not to be confined to Dante and soon began to introduce figures which evoked the influence of Baudelaire. His declared intention was to create a universe, a panorama of the passions and sentiments of humanity. This vast work became a reservoir of forms on which Rodin continuously drew, sculpting a series of groups and "individualised" statues which acquired, as independent works, the status of masterpieces: *The Thinker, The Three Shades* (p.36), *Falling Man* (p.41), *Crouching Woman* (p.44), *She Who Was "La Belle Heaulmière"* (p.45), *Adam* (p.48) and *Eve* (p.49), *Fugit Amor* (p.46), *Kneeling Fauness* (p.47), and many, many others.

Camille Claudel, his model for *Thought* (p. 56), *Dawn*, and for many of the damned of *The Gates of Hell*, was for many years his favourite mistress. She is known to have sculpted some of the feet and hands of that colossal evocation of history, *The Burghers of Calais* (p. 50–51). This commission was made possible by public subscription. Just as he did for his *Balzac* (p. 70), Rodin created his figures nude and then clothed them: "Then I have only to throw a drapery over them and everything comes alive where it touches, it is no cold effigy, but flesh and blood." On this occasion too, not everyone was pleased: "This is not how we picture our glorious compatriots. Their browbeaten attitude offends our pious sentiments…" The monument was nevertheless unveiled in 1895 and Rodin, now a *chevalier* of the Légion d'honneur, became one of the founder members of the Société Nationale des Beaux-Arts. Scandalised reactions were nothing new to him. A revolution in sculpture on the scale of that effected by the Impressionists in painting was bound to create an uproar. "It is quite simple," he said, "the day the public loves the sculpture that I do and that of the young artists who follow me, on that day the teaching at the Beaux-Arts will be worthless." Though his *Balzac* (p. 70) and his *Victor Hugo* (p. 73) were official commissions, and though Rodin was then at the height of his fame, the international acclaim with which they were greeted was accompanied by the most abject vilification.

His Meudon studio had by now become a veritable factory employing more than fifty assistants, from clay moulders to marble carvers. Nor were these mere apprentices; among them figured Pompon, Maillol, Bourdelle and Camille Claudel. When not at work on *The Kiss* (p. 67) or *Iris, Messenger of the Gods* (p. 10), who seems to hurtle through time, exposing what Courbet termed "The Origin of the World", Rodin spent hour upon hour fixing his impressions in sketches which were for the most part erotic; his models were the beautiful women among his clients, his assistants and his occasional models, whom he would ask to take up any position whatsoever, without the least regard for their modesty. For Rodin, who was himself something of a satyr, put an end to centuries of hypocrisy by representing the female sex as reality requires… Isadora Duncan,

who posed for him, tells how this "reincarnation of the god Pan", as she calls him, would ask her to dance nude for him, and how his hot fingers "sculpted her flesh" before returning to the clay.

Shortly before his death, Rodin moved into the Hôtel Biron, to which Rainer Maria Rilke, his sometime secretary, had first drawn his attention. In order to be able to stay there permanently, he donated his works to the French state and set about preparing his museum. And yet, for Rodin, a work was never finished.

He spent his last years playing musingly with his works and with ways of combining them; taking two of his sculptures, he would fit them together to make a third. It was a technique he had already used when juxtaposing the *Hand of Pierre de Wissant* of *The Burghers of Calais* with the mask of Camille Claudel (p. 59). Another example is the collocation of a hand and a nude which constitutes the *Large Tensed Hand with Imploring Figure* (p. 76). One can almost hear him muttering: "Yes, form I have looked at and understood, it can be learnt: but the genius of form has yet to be studied."

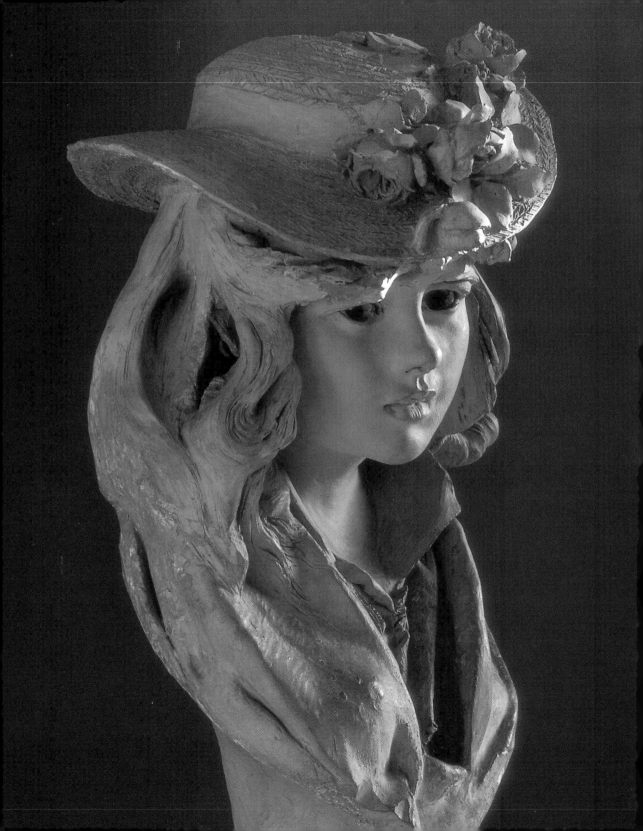

The Mason who Became a Sculptor...

In 1861, when he was 21 years old, Auguste Rodin gave up his studies at the Petite Ecole and the Académie des Gobelins to earn his living. Till then he had confined himself to drawing and painting, studying standard poses such as that in the *Frontal View of a Nude Man (Académie)* (1857, p. 15), where the model rests his weight on a stick. Now he was to begin work as a "statuary-mason" in Haussmann's Paris.

He sought consolation by spending his evenings making busts of his mistress, Rose, whom he had just met; he finally married her fifty-six years later, a few weeks before she died. Marie-Rose Beuret was then a ravishing young seamstress. Alas, the charming features exhibited by the *Young Woman in Flowery Hat* (1865, p. 14) were quick to age and soon came to reflect her disillusionment.

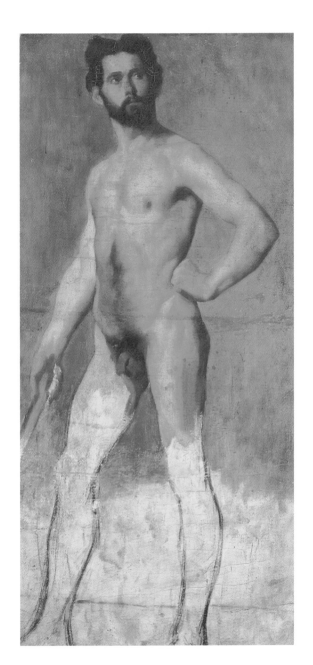

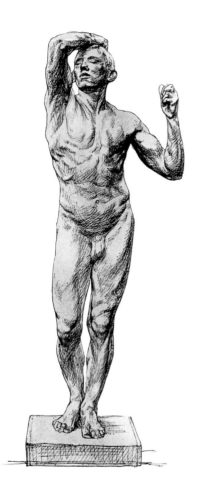

Rodin Accused

On his return from Italy, where he had seen the great works of the Renaissance, Rodin began *The Age of Bronze* (1875–76, p. 17). This was first exhibited in Belgium under the title *The Vanquished*, or *The Wounded Soldier*. The work was apparently intended to commemorate the French defeat of 1870 at the hands of the Prussians. The following year, at the Paris Salon, the statue was greeted with the mixture of admiration and outrage elicited by so many of Rodin's works. Compared to the cold, banal *académies* which were the rule, Rodin's work was so lifelike that he was accused of having moulded it directly on the body of his model. To refute the allegation, and show how far his work was from a sterile copy, he had photographs taken of his model, a Belgian sapper named Auguste Neyt, in the same position as the statue. His efforts were in vain. His good faith was recognised only after his better-known colleagues had signed a petition in his favour. The affair had, however, made Rodin's name, and *The Age of Bronze* was bought by the French state for 2,200 francs, the cost of the casting…

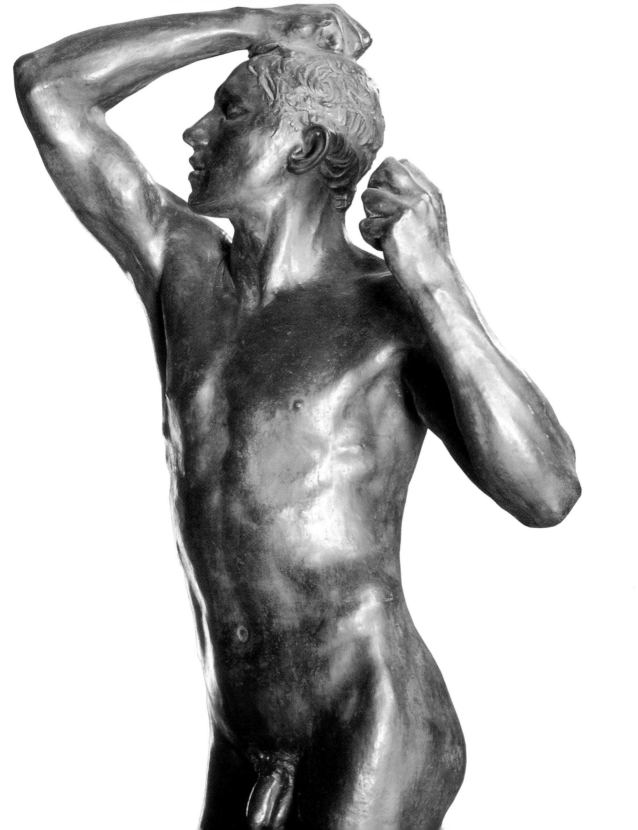

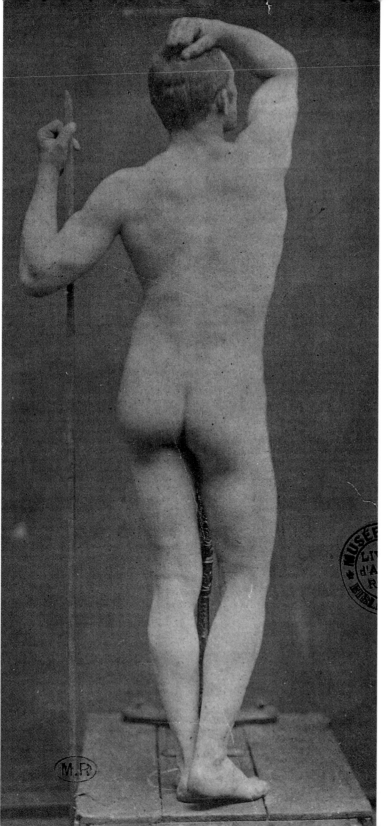

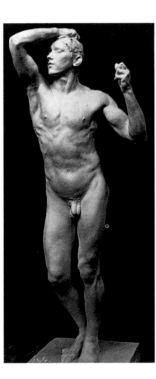

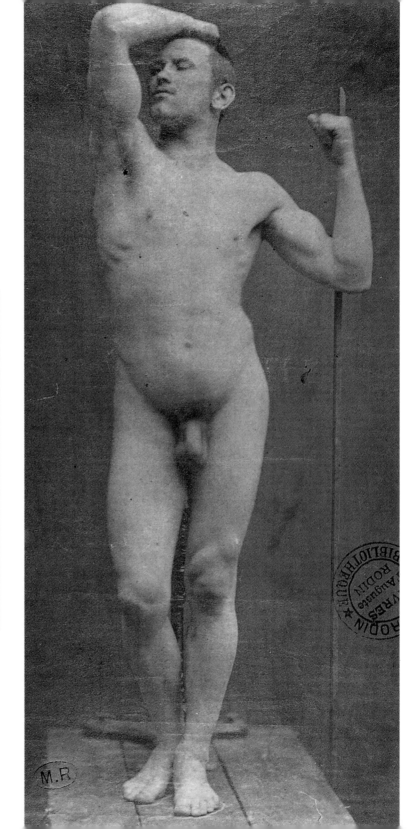

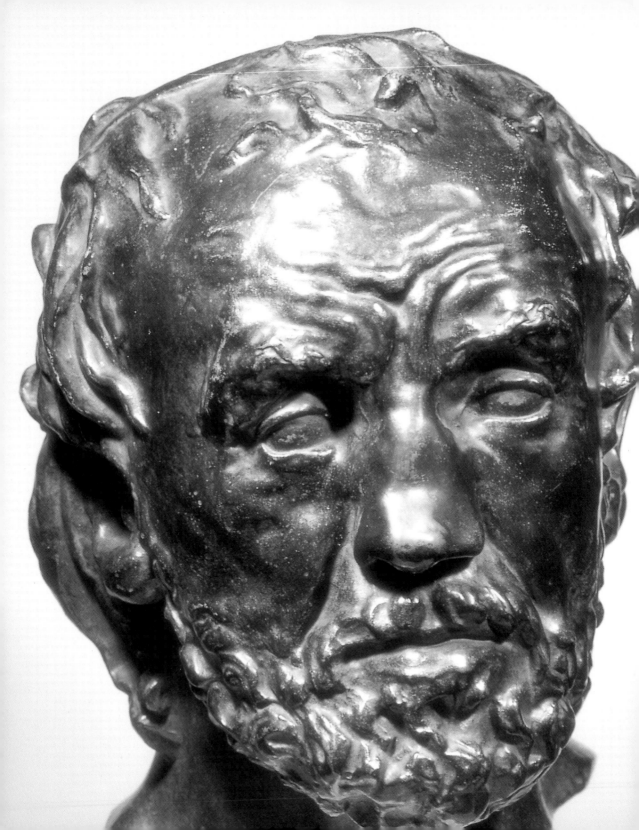

Too Close to Reality

In *The Man with the Broken Nose* (1864, p. 20), which was rejected by the Salon, Rodin produced a work which, in its return to the tormented compositions of Michelangelo, ran directly counter to the prevalent smooth, banal academicism. This head of "Bibi", a sort of tramp who frequented artists' studios, was considered too close to reality. Manet's *Déjeuner sur l'herbe* was rejected at this same period for similar reasons: it was too shocking for the bourgeoisie. Rodin's innovative genius had begun its work, and in 1905 Picasso took up the idea in his *Picador with Broken Nose*.

The *Walking Man* (1877, p. 21), a preliminary study for the *St John the Baptist Preaching* (p. 23) was inspired by the sight of the model posing one leg in front of the other, and one hand thrown forward. Rodin, it is said, exclaimed: "But it's a man walking!" The *Walking Man* is the decapitated St John the Baptist in the style of Roman or Greek statues as we see them today, i. e. mutilated. Rodin has learnt here from the armless *Venus de Milo* and, in his use of a deliberately unfinished form, opens the way for the ovoids of Brancusi and the smooth cloudforms of Jean Arp.

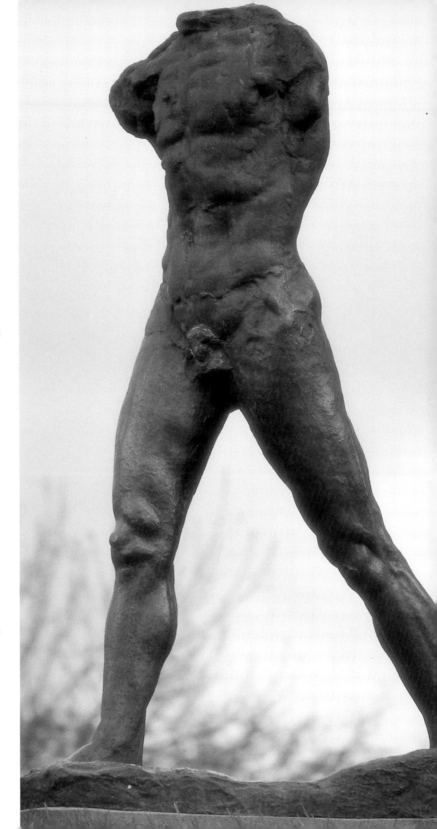

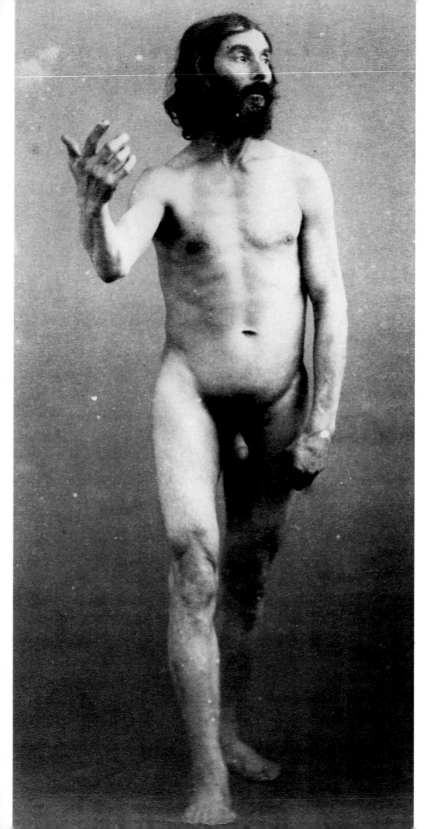

The Giant's Revenge

To take revenge on those who had accused him of moulding from the body, Rodin made his *St John the Baptist Preaching* (1877, p. 23) larger than life. It was composed, like Frankenstein, from a variety of different elements: the *Walking Man* for the body, his friend Danielli for the face, and an Italian for the pose. Judith Cladel, a loyal mistress of Rodin's, describes the model photographed here in the pose of the *St John the Baptist*: "A robust peasant from Abruzzi, called Pignatelli… He undressed, got onto the model's table, planted himself firmly on his feet, and, head up, stretching one arm forward with a proud gesture as he spoke, he stepped forward. With his shaggy growth of hair and sparkling eyes, he was a kind of savage: 'He's like a wolf,' said Rodin." The *St John* originally carried a cross on his shoulder, but this broke the sweep of the composition and Rodin left it out.

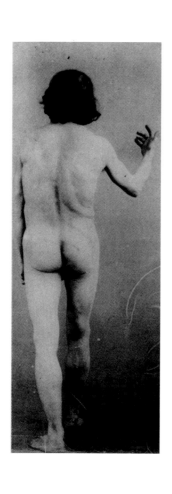
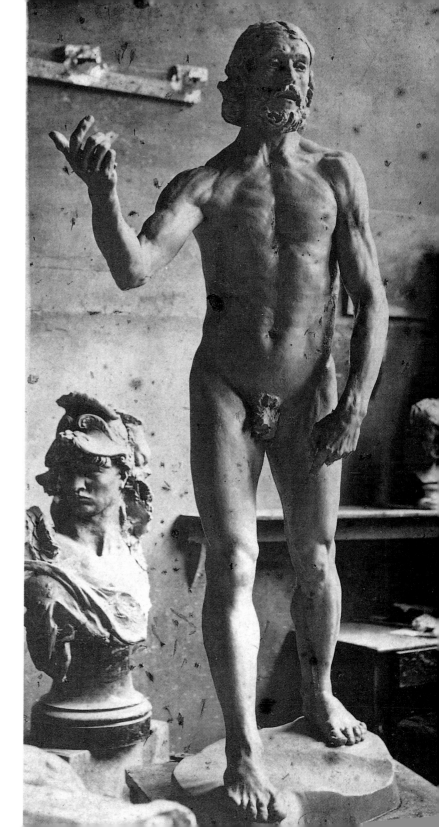

The Sculptor and His Model

Rodin had no qualms about using photography in the composition of his works. One example is this woman lying back in a gesture of abandon; turned upside down, it inspired the drawing beside it, and subsequently the wonderful sculpture of the torso of Adèle, one of his models and his favourite mistress. There is an admirable logic and continuity to the way in which one work gives rise to the next in Rodin's œuvre. The *Torso of Adèle* (c. 1882, p. 24–25) radiates sensuality and eroticism and clearly suggests the intimate relations that existed between the sculptor and most of his models.

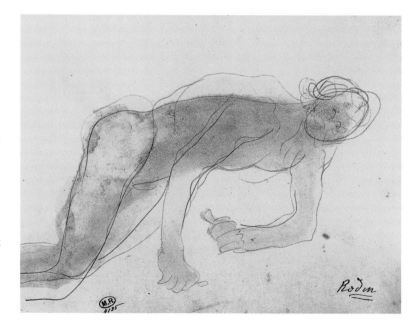

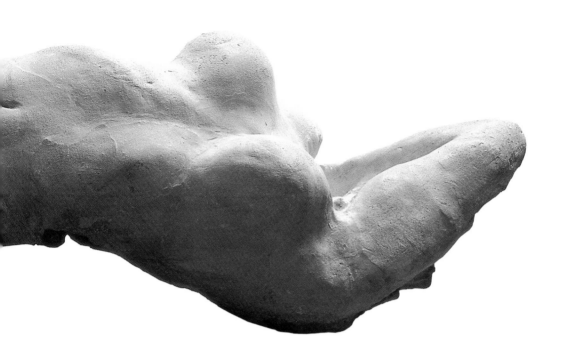

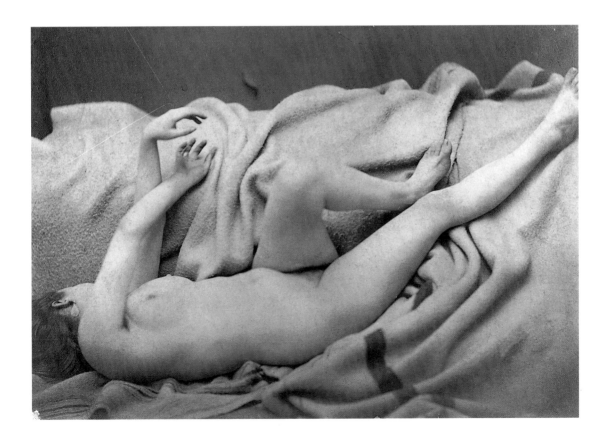

The Gates of Hell

T hough academicians and journalists constantly railed at Rodin, he did not lack supporters. Nor were these insignificant people; they included well-known politicians such as Léon Gambetta, writers as illustrious as Pierre Loti or Sully Prudhomme, and musicians as renowned as Charles Gounod, then a celebrated name throughout Europe. It was a petition signed by these supporters that secured him commission to create an ornamental gate for the Musée des arts décoratifs; it was to represent the *Divine Comedy* of Dante. This became the celebrated *Gates of Hell* (1880–1917, p. 28–29). Rodin's initial conception, combining the spirit of Dante and the forms of the Renaissance, gradually changed to embrace the fantasies of Baudelaire and the forms of Romanticism. Rodin spent more than forty years on the *Gates*, and they were unfinished at his death; they became the crucible in which all his ideas, all his creations were tested. Originally conceived as an "infernal"

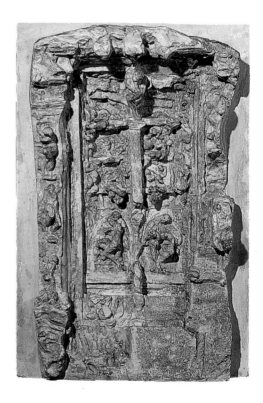

response to Ghiberti's structured and orderly "Gates of Paradise", Rodin's *Gates* are all disorder and chaos. "I shall make a quantity of small figures," he declared, "that way I cannot be accused of casting from life..."

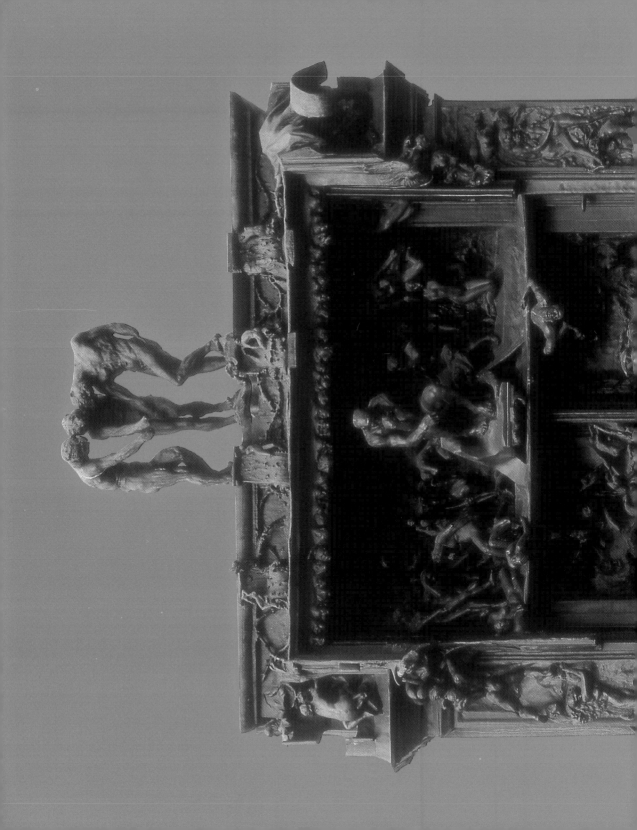

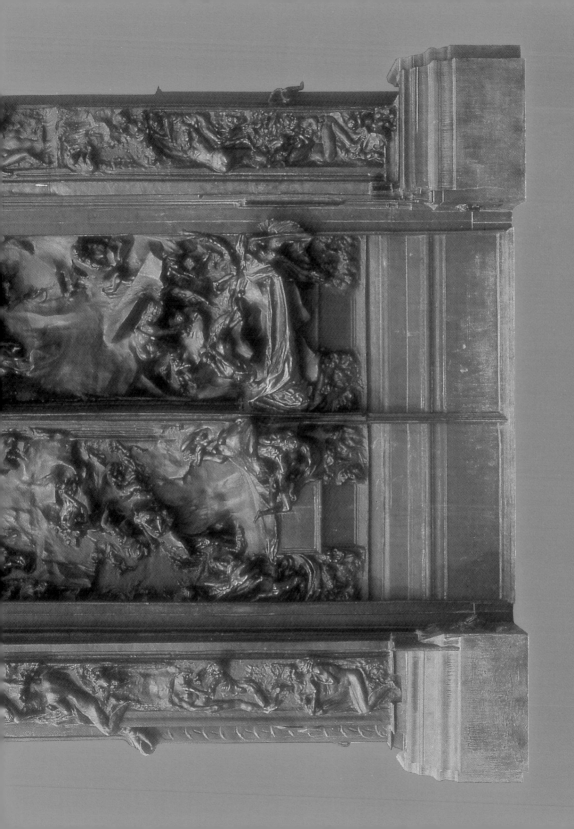

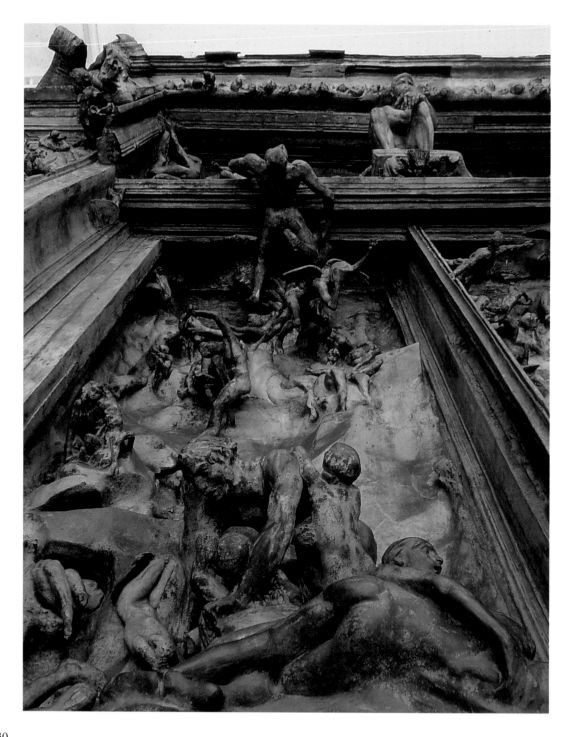

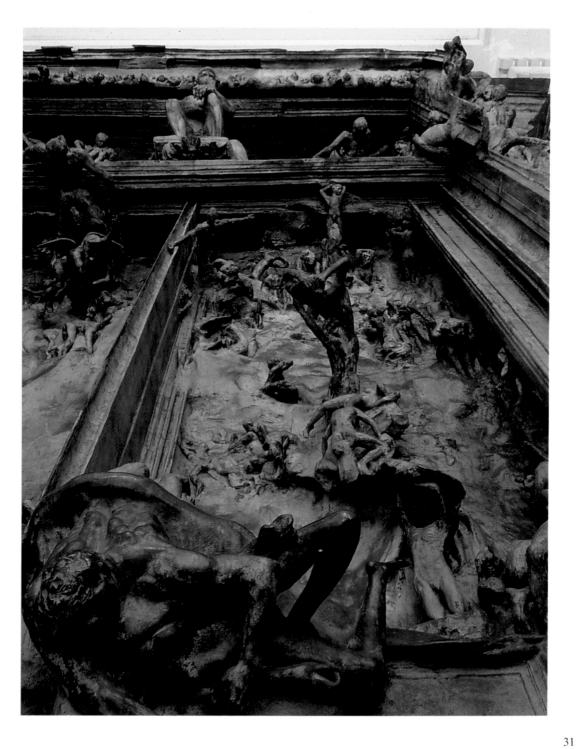

A Shudder of Tragedy

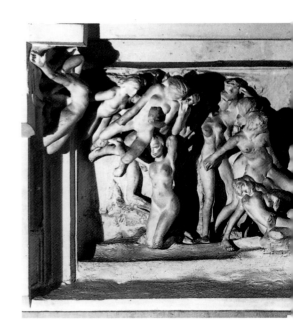

Rodin was forty when he set about
this vast work. For once, the in-
spector ordered to report on the pro-
gress of the work, Roger Ballu, was a
man of perception. His report was en-
thusiastic: "Monsieur Rodin is
haunted by Michelangelesque visions;
he may astonish the spectator, he will
never bore him…" The *Gates* "will
make their mark as a unique creation
of great originality; they may be
criticised for violating established
principles or conventions. They will
be acknowledged for the energy they
seek to manifest, for their vitality ex-
ceeding the bounds of stylistic execu-

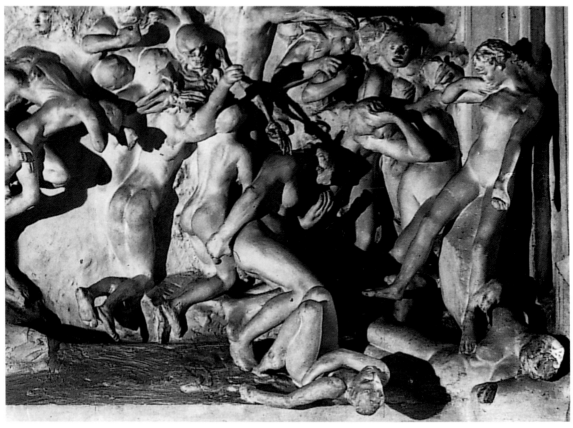

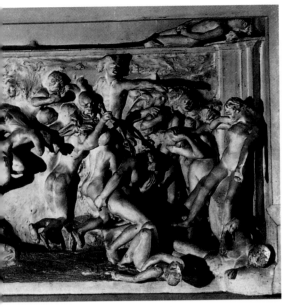

tion. They will truly be, in the full strength of the word, a work of art... Each body pitilessly obeys the passion by which it is animated, each muscle follows the impulse of the soul. Even in the most bizarre outlines and the most twisted forms, the characters are logical in relation to the destiny with which the artist has marked their rebellious and punished humanity. In this atmosphere pervaded by a sense of Rodin's genius, he causes us to experience a shudder of tragedy."

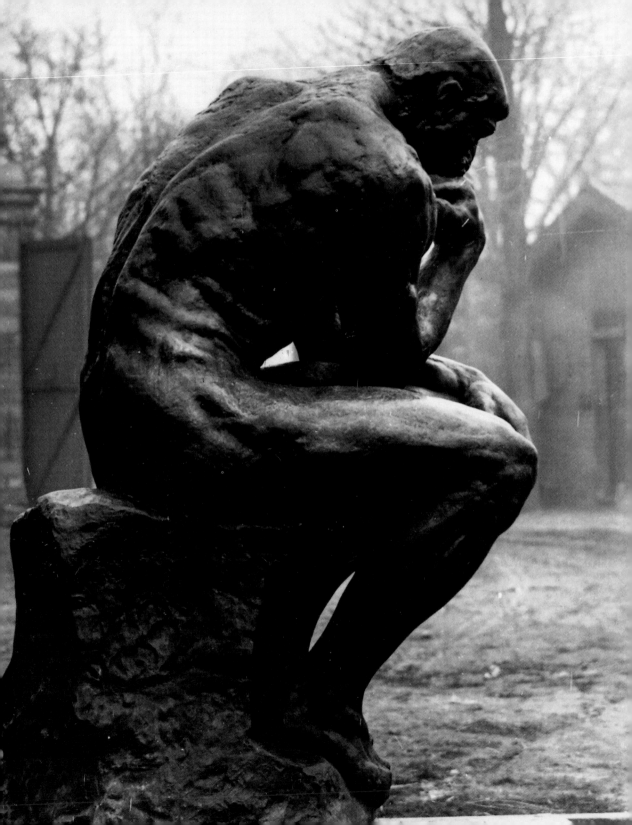

Apollo Belvedere in the Vatican Museum as well as to the statue of the seated Lorenzo de' Medici and to Michelangelo's *Moses*. What distinguishes Rodin from his predecessors is his way of expressing the effort of thought through the contraction of each and every muscle; the work of the mind thus becomes palpable.

The Thinker: Muscle and Mind...

*T*he Thinker (1880, p. 34) is perhaps the most famous work in Rodin's œuvre. Though an independent work in its own right, it was originally intended to occupy the summit of the *Gates* and to represent Dante meditating on his creation. But in Rodin's mind, the meaning of *The Thinker* developed from a representation of Dante into a more general image of man meditating: of the human who, in a convulsive effort to rise above animal life, is inspired by a mysterious illumination, and gives birth to the first thought. In its form, *The Thinker* owes much to classical art, in particular to the *Torso of the*

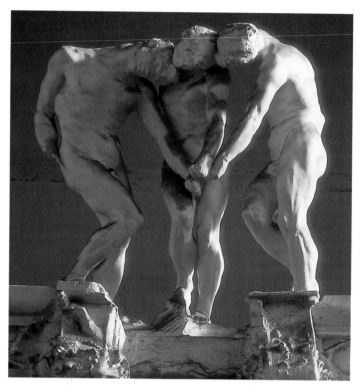

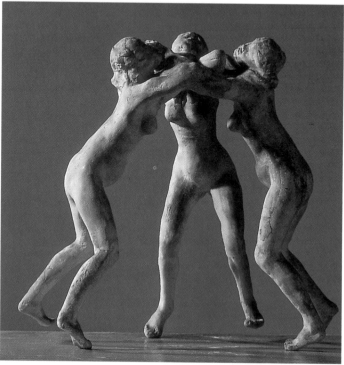

The Multiplication of Forms

To add strength to the figures which appear over the *Gates*, Rodin simply multiplied existing forms. One example is *The Three Shades* (1880, p. 36 top), which is a threefold version of *Adam* (p. 48) expelled from Paradise. The same method was used for *The Three Faunesses* (p. 36 bottom), also called the *The Three Graces Dancing*; this is the first representation of dance in Rodin's work. Here the sculptor has not troubled himself with excessive anatomical detail. The forms are only suggested, for what is represented is not a sensation or an emotion, but an action, a movement: dance.

Under two varying titles, *Kneeling Fauness* (c. 1884, p. 37) or *The Toilet of Venus* (1885, p. 64), Rodin uses the same gesture – hands reaching behind the head – to emphasise the contours of the bust. These nudes, with their slanting eyes and strong mouths, are strongly expressive of sensuality. Was this sensuality the cause of man's fall? *Meditation* (1885, p. 37) might have dwelt on this question, at least until she came to form part of the monument to Victor Hugo, when she changed her name to *The Inner Voice* in homage to one of Hugo's collections.

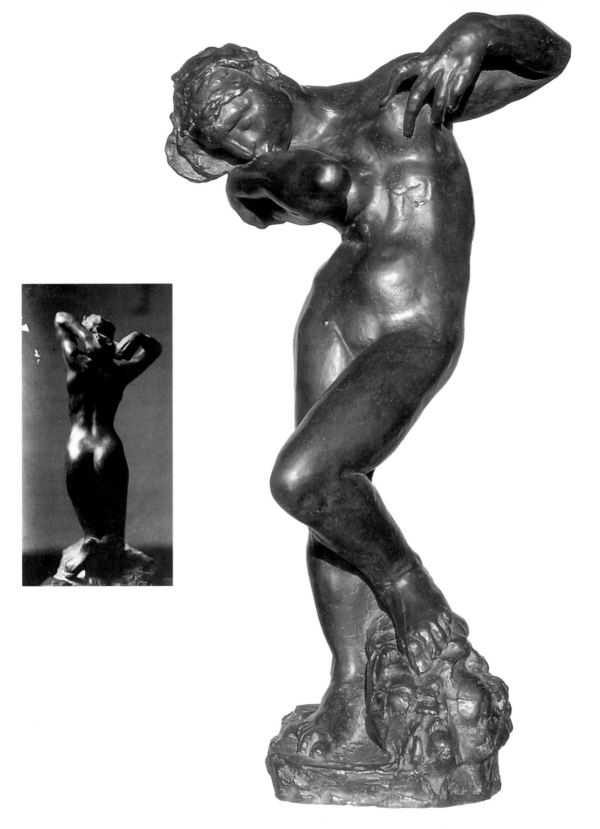

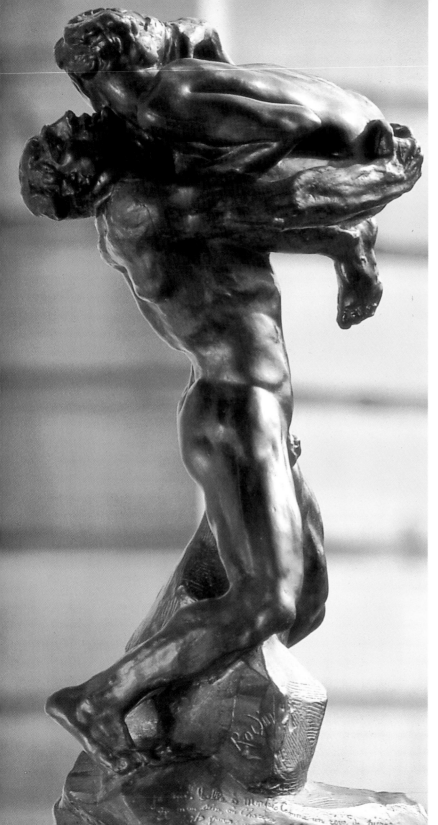

Baudelaire's Fantasies

I am beautiful, o mortals, like a dream of stone / And my breast on which each in his turn has been bruised / Is made to inspire in the poet a love / Eternal and speechless as matter itself."

Baudelaire's poem "La Beauté" exemplifies the inspiration which filled Rodin at a time when he was illustrating *Les Fleurs du Mal.* It is Baudelaire's influence that we find in the group of *Damned Women* (p. 65). The work with the title *I am beautiful* (1882, p. 38), a representation of *amour fou,* is, in characteristic Rodin fashion, made up of two other statues: *Crouching Woman* (p. 44) is lifted up and embraced by *Falling Man* (p. 41). This method was often used by the sculptor, who wasted nothing; the results were often astonishingly homogeneous and powerfully expressive. In the same way *The Fall of Icarus* (1895, p. 39) is none other than the *Martyr* (p. 33) turned on her front and equipped with a pair of wings.

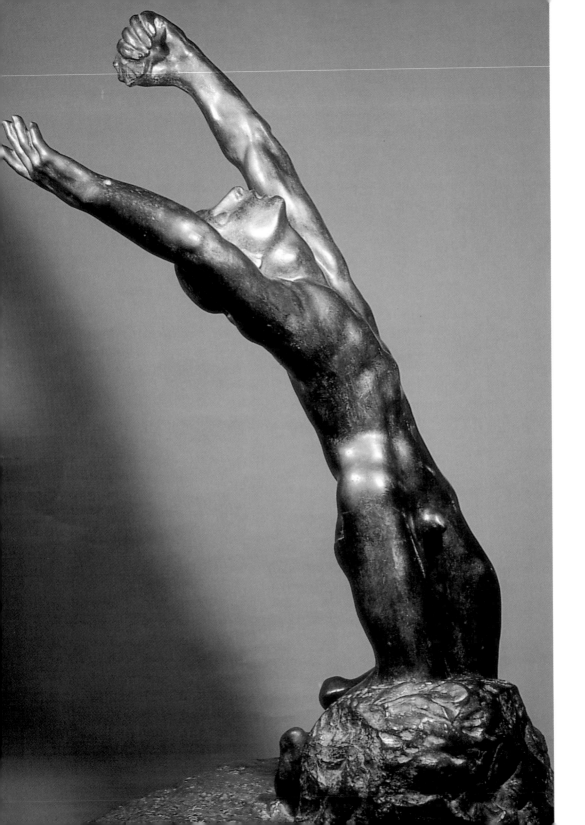

The Despair of the Man Struck down by the Gods

In a pitiful gesture of supplication or revolt, *The Prodigal Son* (1889, p.40) stretches his arms towards the heavens. In this work, which can be seen in the right-hand panel of the *Gates*, and which was exhibited variously under the titles *The Child of the Century*, *The Prayer of the Abandoned Child*, *Vae Victis* and *The Warrior*, Rodin sought to express the desperate psychological tension of the character: "I made the muscles project emphatically to express distress... I exaggerated the separation of the tendons to show the ardour of the prayer..." *The Prodigal Son* was adapted to compose *Fugit Amor* (p.46), while its face in isolation became the celebrated *Head of Sorrow* (p.60), which inspired many painters, notably Munch. The *Falling Man* (1882, p.41), seen embracing Beauty in *I am Beautiful* (p.38), can thus be found simultaneously in several different parts of the *Gates*, here as the passionate lover who raises his beloved to his lips, there as the man struck down by the gods and descending into Hell.

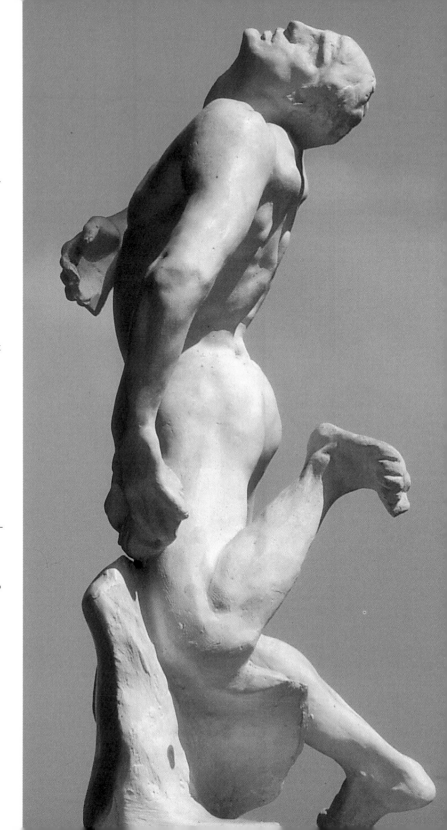

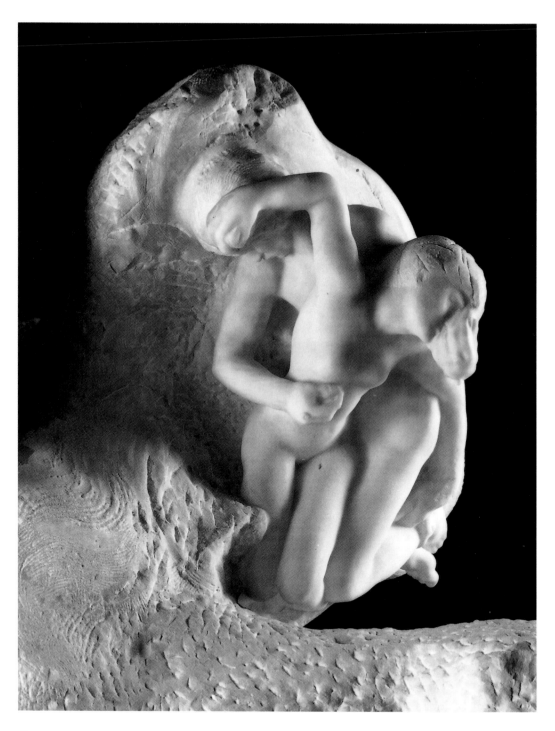

Sensuality and Pessimism

Like many of the couples represented in the *Gates of Hell*, *Paolo and Francesca* (1887, p. 42) symbolize *amour fou*: they are lovers bound together for eternity. The force of love drew Paolo Malatesta and Francesca da Rimini – murdered in a famous episode of the *Divine Comedy* by Giovanni, husband of Francesca and brother to Paolo – into sin, death and the damnation of eternal desire, where they are cast in their inseparable embrace.

The *Danaïd* (1884–85, p. 43), on the other hand, is one of those sculptures in which Rodin expresses despair and the expectation of death through forms folded back on themselves as though oppressed by a weight of calamity. For Rodin, sensuality and pessimism go hand in hand. The *Danaïd* was originally intended for the *Gates*, but does not figure in the finalised montage, and has thus been handed down to us as an independent work.

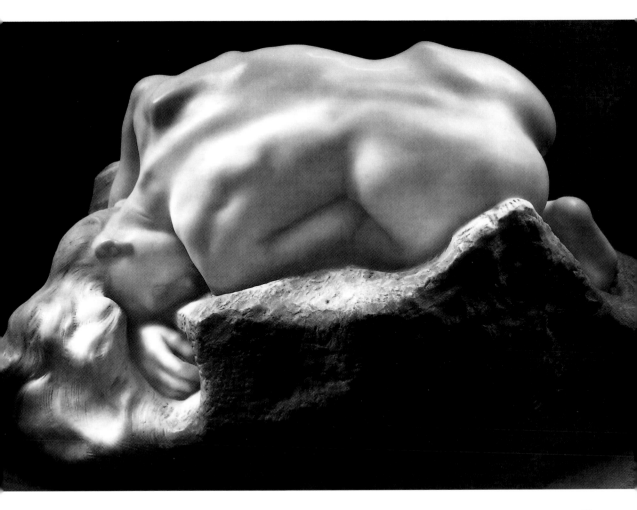

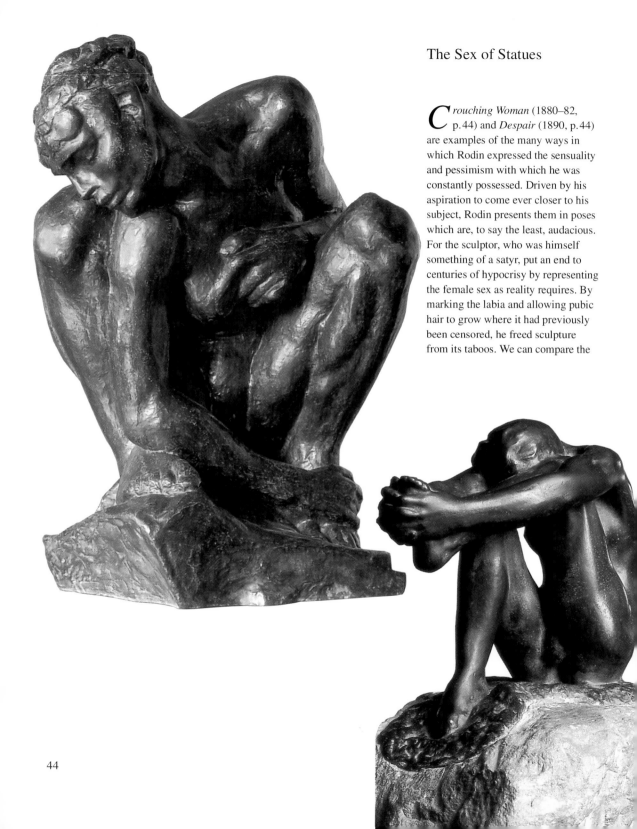

The Sex of Statues

*C*rouching Woman (1880–82, p. 44) and *Despair* (1890, p. 44) are examples of the many ways in which Rodin expressed the sensuality and pessimism with which he was constantly possessed. Driven by his aspiration to come ever closer to his subject, Rodin presents them in poses which are, to say the least, audacious. For the sculptor, who was himself something of a satyr, put an end to centuries of hypocrisy by representing the female sex as reality requires. By marking the labia and allowing pubic hair to grow where it had previously been censored, he freed sculpture from its taboos. We can compare the

figures shown here with *Iris, Messenger of the Gods* (p. 10), who spreads her thighs to reveal an opening that the Greeks termed "the infernal cave"; Rodin himself gave to *Iris* the evocative title of *Eternal Tunnel*.

She Who Was "La Belle Heaulmière" (The Helmet-Maker's Beautiful Wife; 1880–83, p. 45), on the other hand, is probably the only representation in Rodin's work of an old woman; he much preferred to portray the young and beautiful. The story goes that an Italian woman had come on foot to take a last leave of her son, one of Rodin's models; she was brought before the sculptor who, in his fascination, wrought this astounding representation of old age. Klimt had the statue in mind when he painted his *Three Ages of Life* in 1905.

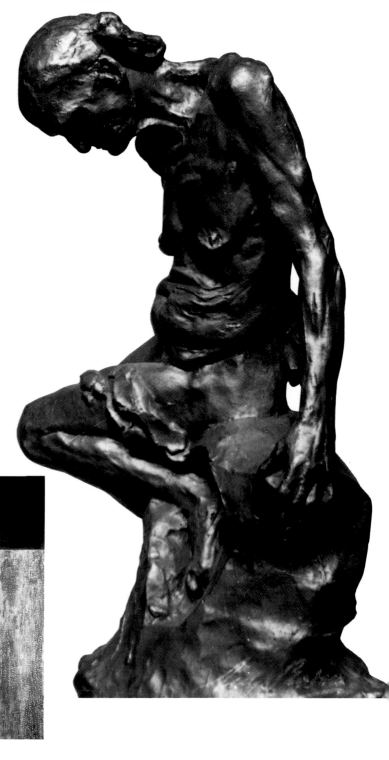

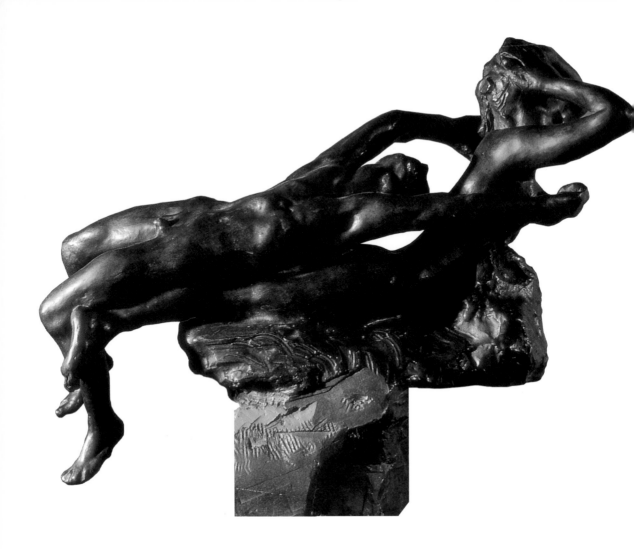

Elusive Beauty

Fugit Amor (c. 1887, p. 46) is a
further treatment of the theme of
Paolo and Francesca, the tragic lovers
from Rimini who feature in various
parts of the *Gates of Hell*, in particu-
lar in the centre of the left-hand panel
and on the summit of the right-hand
panel, where the figures are reversed.
This work goes beyond the carnal as-
pect of human love to show the elu-
sive appeal of beauty, as symbolised
in the woman fleeing from the out-
stretched arms of the man who tries
vainly to hold her back. Like the
Kneeling Fauness (1884, p. 47), this
sculpture was, in Rodin's time, a best-
seller produced in substantial numbers.

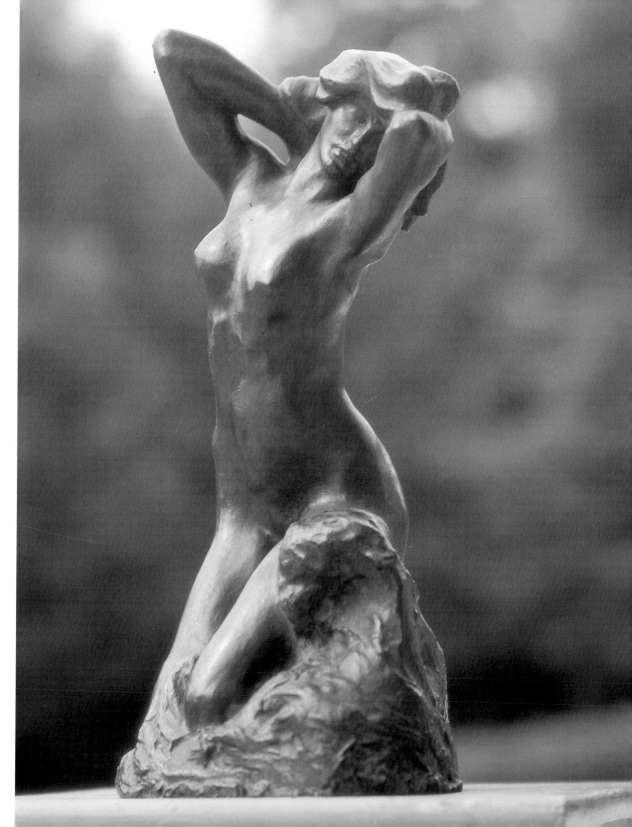

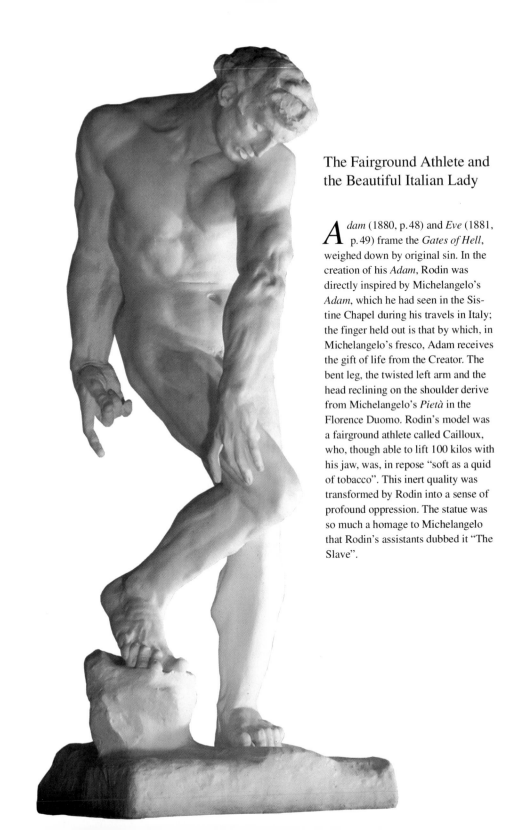

The Fairground Athlete and the Beautiful Italian Lady

*A*dam (1880, p. 48) and *Eve* (1881, p. 49) frame the *Gates of Hell*, weighed down by original sin. In the creation of his *Adam*, Rodin was directly inspired by Michelangelo's *Adam*, which he had seen in the Sistine Chapel during his travels in Italy; the finger held out is that by which, in Michelangelo's fresco, Adam receives the gift of life from the Creator. The bent leg, the twisted left arm and the head reclining on the shoulder derive from Michelangelo's *Pietà* in the Florence Duomo. Rodin's model was a fairground athlete called Cailloux, who, though able to lift 100 kilos with his jaw, was, in repose "soft as a quid of tobacco". This inert quality was transformed by Rodin into a sense of profound oppression. The statue was so much a homage to Michelangelo that Rodin's assistants dubbed it "The Slave".

Eve is a much more personal work. It portrays a beautiful Italian women of full, round muscles: "a panther", in Rodin's description. At each session, Rodin, unsatisfied, would revise the outline of his maquette, till the day came when the model confessed that she was pregnant… Rodin left the work incomplete, but the slight swelling of maternity makes her an all the more eloquent evocation of *Eve* as the mother of humanity.

Happy Ending for the Burghers

According to the medieval chronicler Jean Froissard at the siege of Calais by the English in 1347 King Edward III agreed to spare the population on condition that six of the most notable of the burghers of the town came to him bareheaded, barefoot, a rope around their necks, to deliver up the keys of the city. This was the scene that the city of Calais commissioned Rodin to represent. It took him ten years, dogged by criticism and uncertainty, before the monument, a block weighing 2,200 kg, was unveiled in Calais on 3 June 1895. The group was vilified on almost every count: it was demoralising, it lacked grandeur, it was not elegant... Rodin persevered and succeeded in imposing his own vision, insisting that the group be placed at ground level and not on a plinth. And the great triumph of *The Burghers of Calais* (1884–86, p. 50–55) was that a cast was taken to be placed in Parliament Gardens in London in 1913. For in England it had not been forgotten that this was one tragic story with a "happy ending".

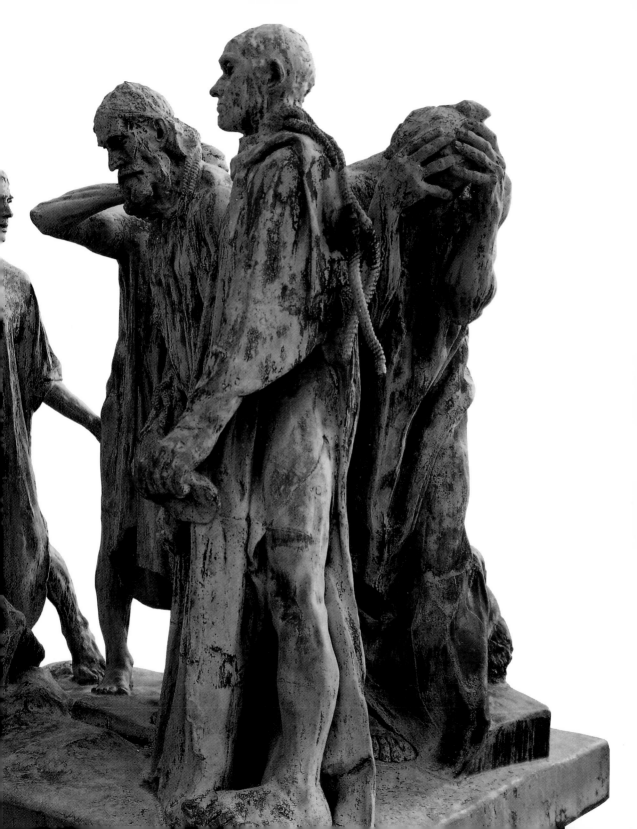

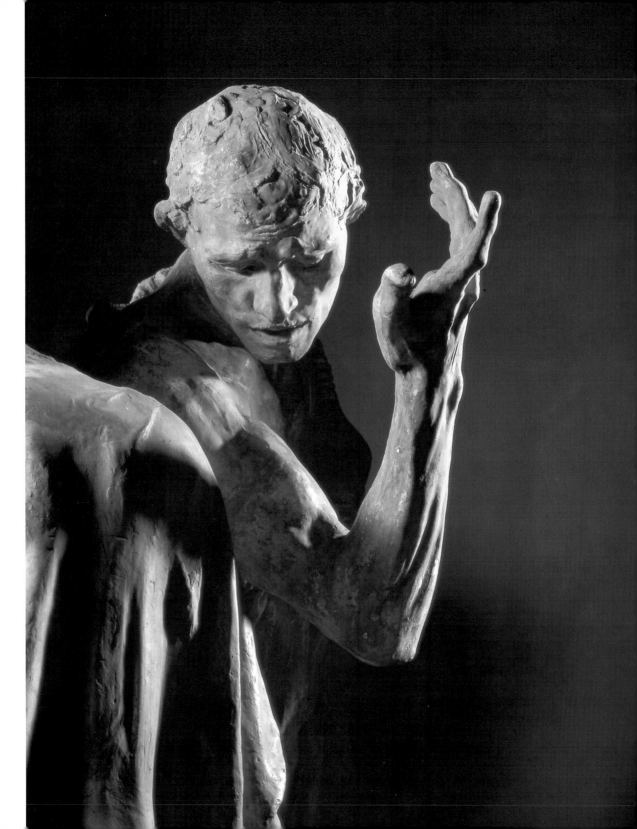

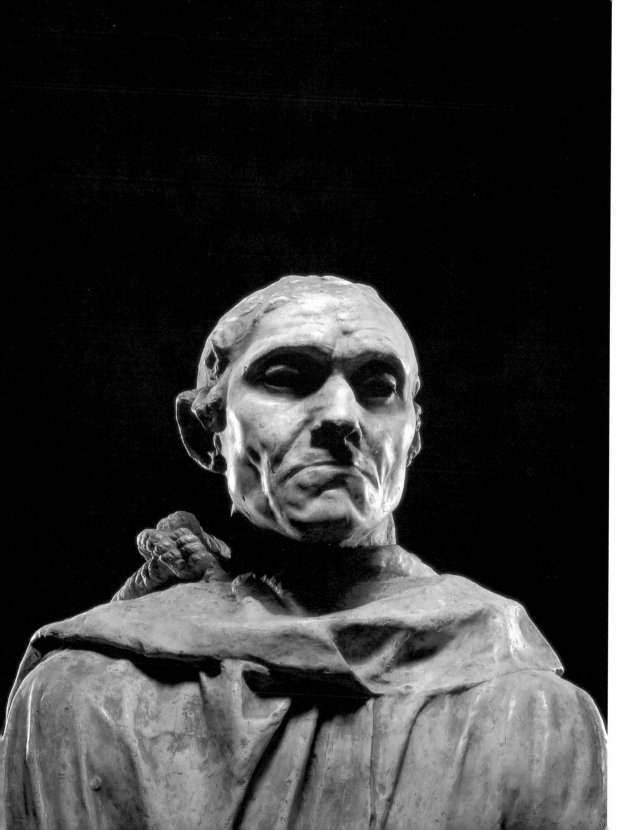

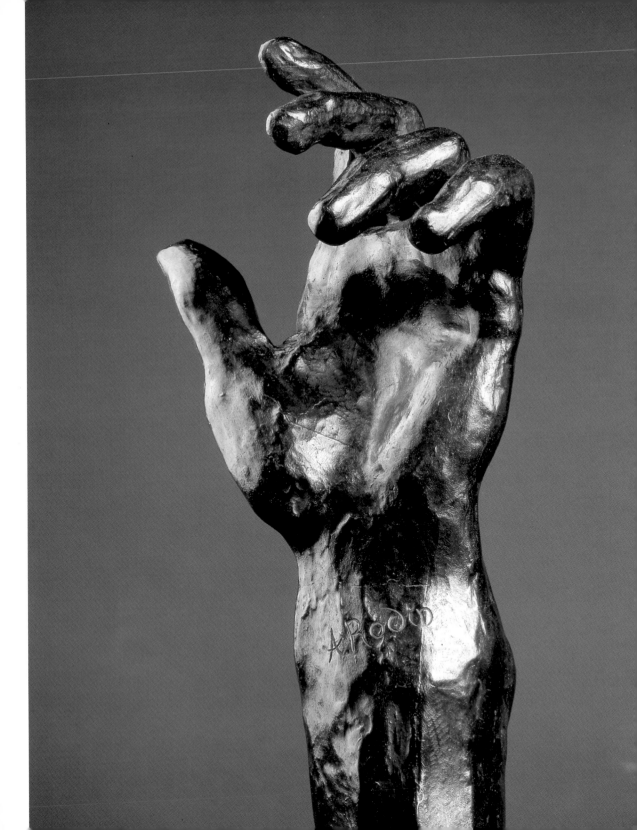

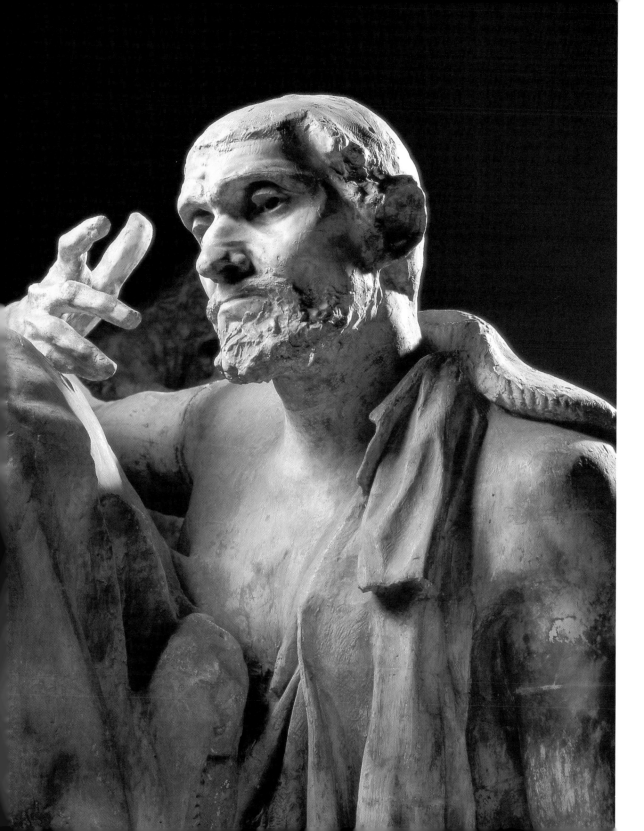

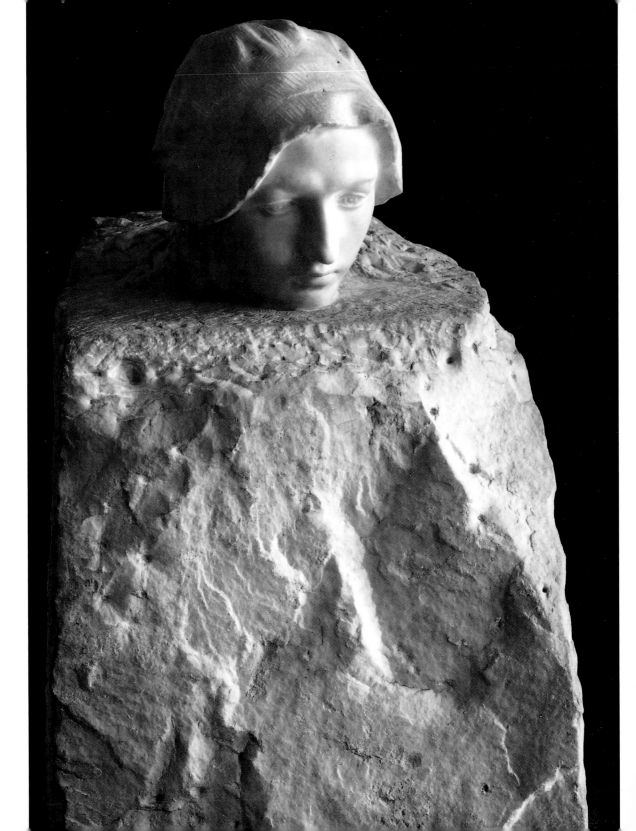

The Bridal Headdress

For his 1886 sculpture, *Thought*, Rodin made use of the moving lineaments of the face of Camille Claudel, then his student, already his mistress, and soon to be his assistant. She was twenty-two, he was forty-six. Their stormy affair lasted more than fifteen years, and Camille's beauty, strong personality and uncompromising nature were a source of inspiration to Rodin, who spoke of her in high terms: "I have told her where to find gold, but the gold that she finds is all her own." The affair ended badly, and Camille spent her latter years in a mental asylum. Here, she wears the Breton bridal headdress, the nuptial headdress that symbolises intransigent faith, and which Rembrandt and Van Gogh had represented before Rodin. Camille was never to wear it in real life.

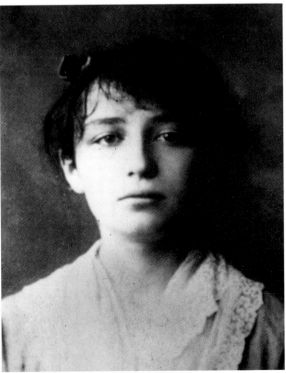

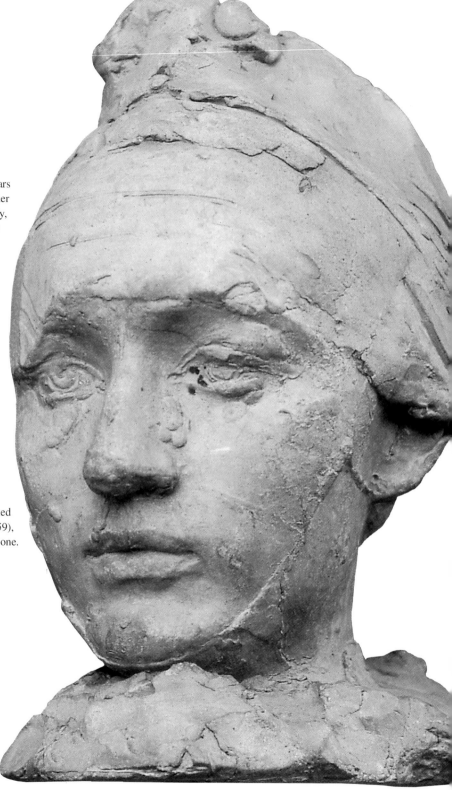

Calm before the Storm

Camille is now twenty-five years old and this time Rodin has her wear a Phrygian cap. Exceptionally, the *Camille with Phrygian Bonnet* (1886, p.58) was made in glass paste, a soft, fragile substance which Rodin no doubt associated with the fragility of his mistress. What is striking in this face is the apparent absence of fire or passion, the fixity of the stare, as though Rodin had foreseen beyond this calm the storm under the impact of which Camille's mind gave way. Camille, with her thirst for the absolute, wanted to be the only woman… Rodin saw beauty everywhere. Rodin had set his mark upon Camille, as this *Bust of Camille Claudel*, to which he affixed the *Hand of Pierre de Wissant* (p.59), suggests; but she was not the only one.

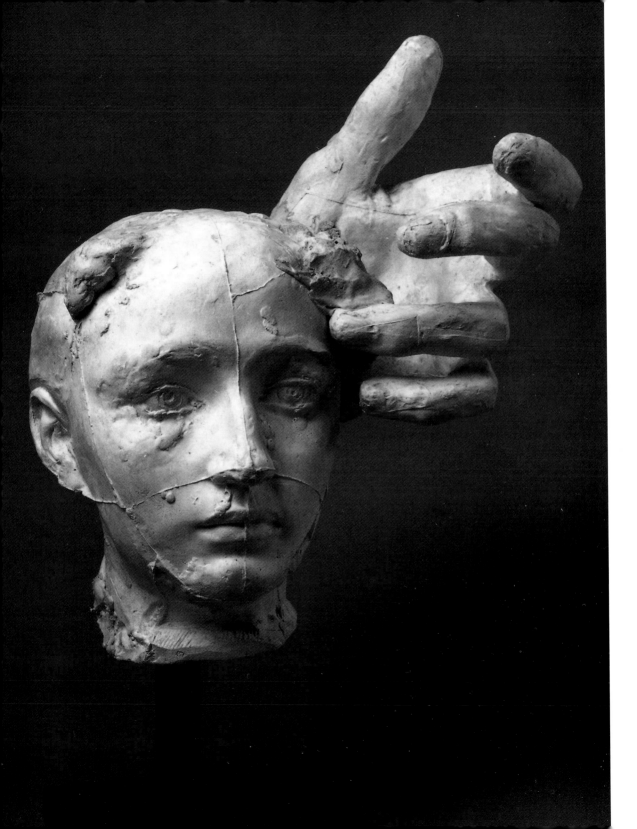

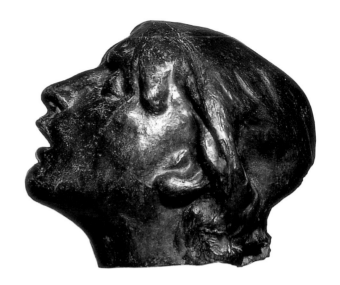

Art Is Life

The *Head of Sorrow* (1882, p. 60) and *The Scream* (1899, p. 61) by Rodin, like Edvard Munch's *Scream* of 1893, were engendered by fear and anguish. These works have a single purpose: the representation of emotion. Rodin declared: "Even in those of my works in which action is least emphasised, I have always sought to put some suggestion of gesture: I have very rarely represented complete repose. I have always tried to render inner feelings through the mobility of the muscles… Without life, art does not exist."

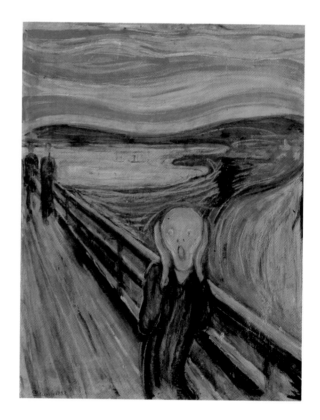

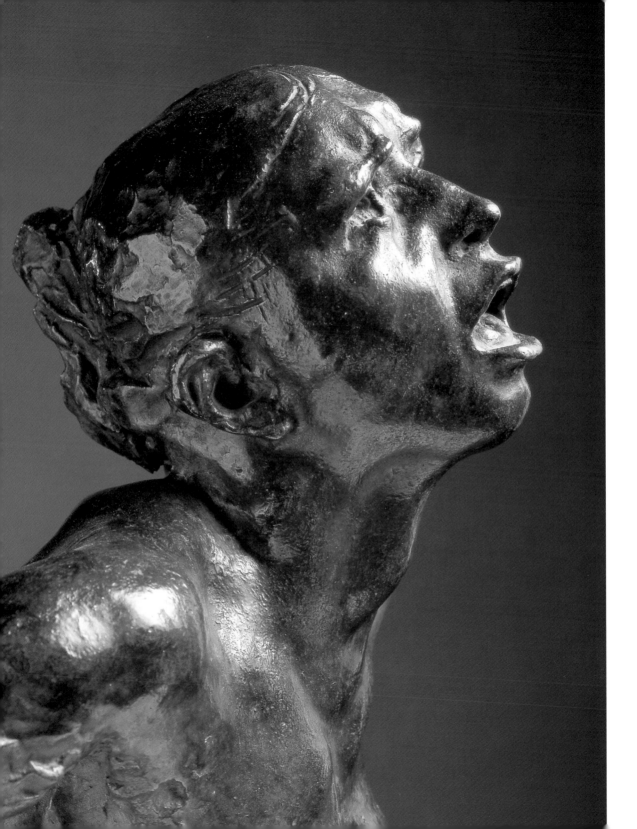

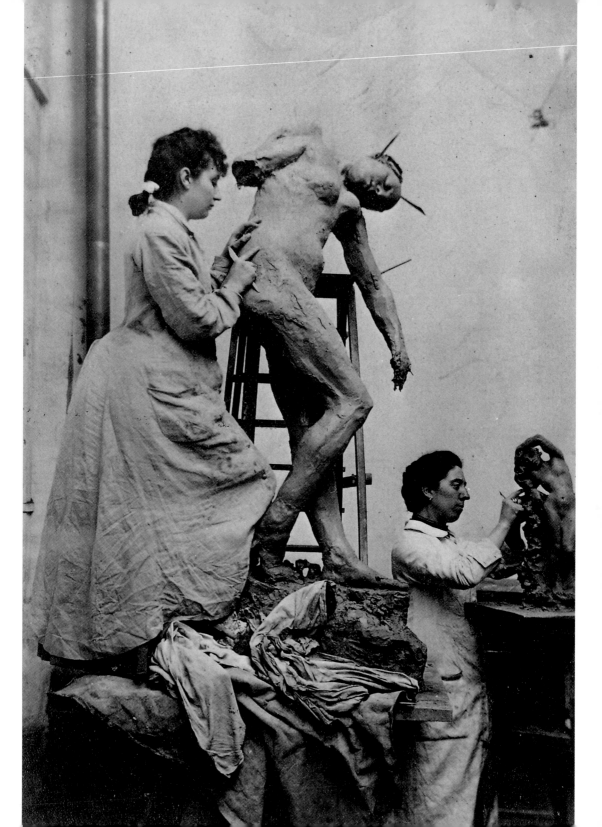

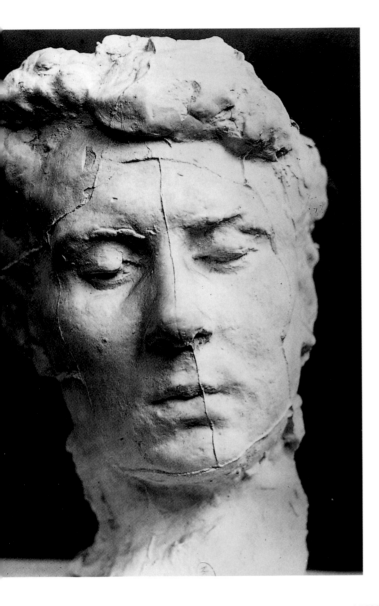

wrote to her affectionately: "I think of you and I am at peace, my work is in your hands, don't moisten too much, use your finger to check." Rose put up with everything and to the very end she called him "maître" (maestro, master). In 1890, when she was thirty-six, he made this *Bust of Rose* (p. 63). Its severity of expression suggests a mute reproach. Suffering abounded in her life as did women in Rodin's, and it shows.

Not too Moist…

It was not Camille, the demanding mistress – seen here (p. 62) sculpting alongside another of Rodin's assistants – but Rose, his submissive companion, who had the firmest hold on Rodin's affections. Around 1893, he wrote to her: "My dear Rose, to-night I am returning to you." Rose had always had an important role as guardian of his work.

She had spent her life moistening the clay so that it did not crack. Even when he was with Camille, Rodin

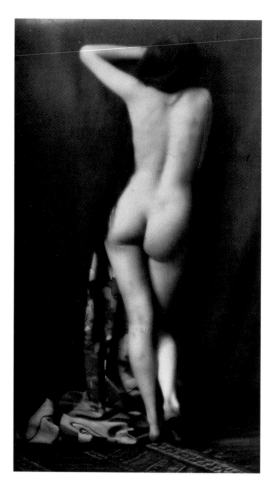

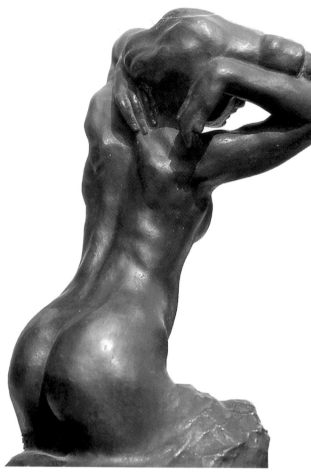

The Erotic Beauty of the Female Body

The great thing is to be moved, to love, to hope, to shudder, to live. To be a man before being an artist!" In relation to women, Rodin left Dante and Michelangelo aside and gave himself up to the influences of Baudelaire and Pan. His sculptures become smooth as flesh, sensual and playful like a young girl for whom her body is a new discovery. This facet of

his art found expression in works of a charming sensuality, like this *Toilet of Venus* (1885, p.64), reminiscent of the *Kneeling Fauness* (p.37), since the model for both these works was another mistress, Mme Abruzzeti. Rodin's love of women is clear in the photograph (p.64) which inspired the sculpture. It is clear too in *Damned Women* (1885, p.65), a homage to

Baudelaire which has nothing to do
with the Inferno. The eroticism of
Sapphic couples had already inspired
fine works by Courbet, Degas and
Toulouse-Lautrec.

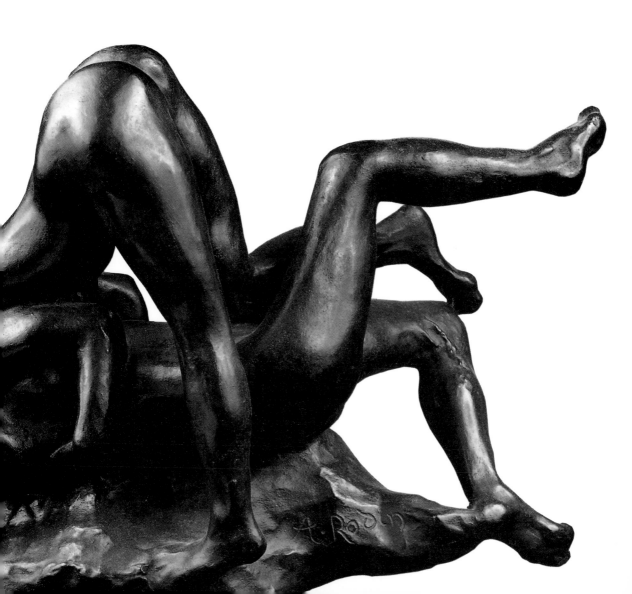

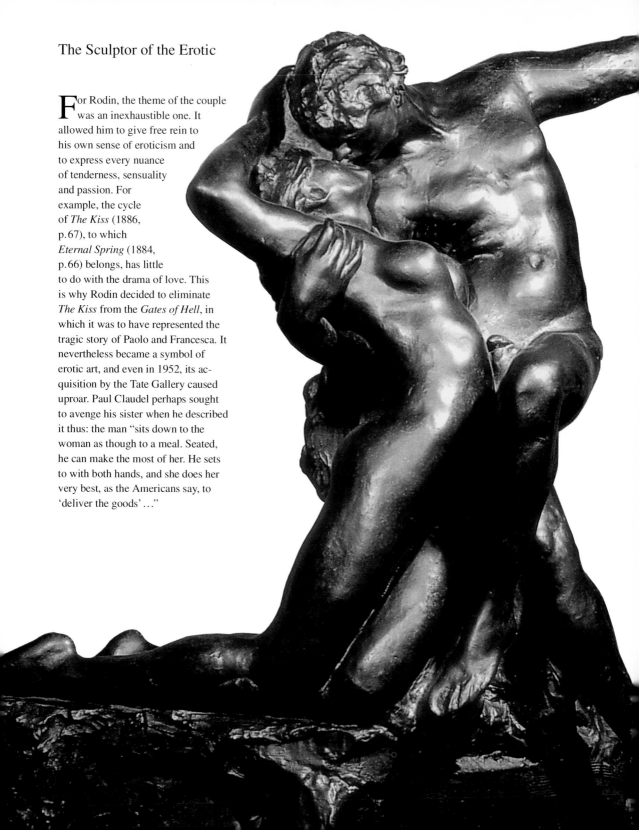

The Sculptor of the Erotic

For Rodin, the theme of the couple was an inexhaustible one. It allowed him to give free rein to his own sense of eroticism and to express every nuance of tenderness, sensuality and passion. For example, the cycle of *The Kiss* (1886, p.67), to which *Eternal Spring* (1884, p.66) belongs, has little to do with the drama of love. This is why Rodin decided to eliminate *The Kiss* from the *Gates of Hell*, in which it was to have represented the tragic story of Paolo and Francesca. It nevertheless became a symbol of erotic art, and even in 1952, its acquisition by the Tate Gallery caused uproar. Paul Claudel perhaps sought to avenge his sister when he described it thus: the man "sits down to the woman as though to a meal. Seated, he can make the most of her. He sets to with both hands, and she does her very best, as the Americans say, to 'deliver the goods'…"

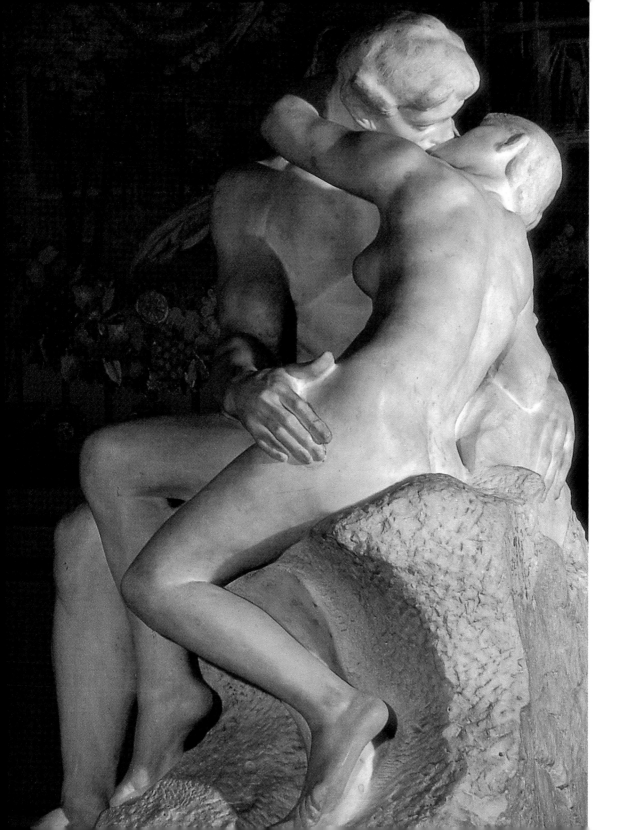

A Gigantic Foetus

The *Monument to Balzac* was commissioned by the Société des Gens de Lettres in 1883 as a homage to the novelist Honoré de Balzac (1799–1850). Of all Rodin's œuvre, it is this work which most clearly inaugurates the sculptural language of the 20th century. Rodin's *Balzac*, far ahead of its time, paved the way for new expressive possibilities in sculpture, first and foremost in its rejection of servile imitation, secondly in its daring simplification of form. Rodin himself said of the work: "Nothing else that I have done satisfies me as much, because nothing else cost me so much effort, nothing else so profoundly summarizes what I believe to

be the secret law of my art." Photographs, masks, dressing-gown, nude studies, and sketches accumulated before Rodin's vast labours issued in the final version, the *Clothed Balzac* (1897, p. 70). In this work Rodin brought to a culmination his aspiration to record not so much the physical appearance of the writer as the very essence of his personality. The reaction was virulent: "sack of coals… penguin… shapeless grub… foetus…" and the Société des Gens de Lettres rejected the statue despite the protests of such contemporary luminaries as Monet, Toulouse-Lautrec, Signac, De-

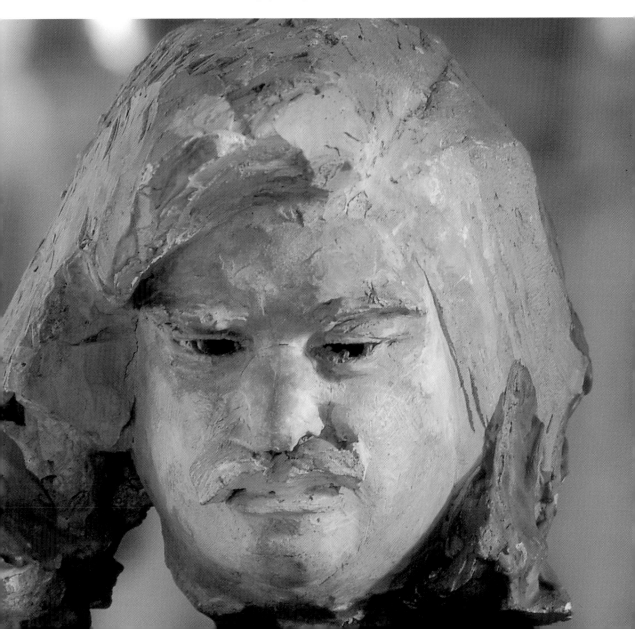

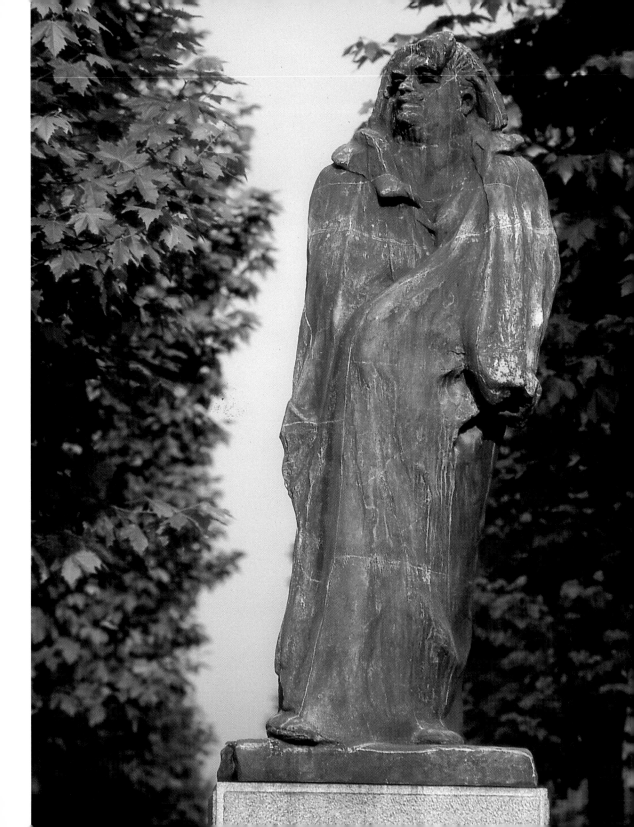

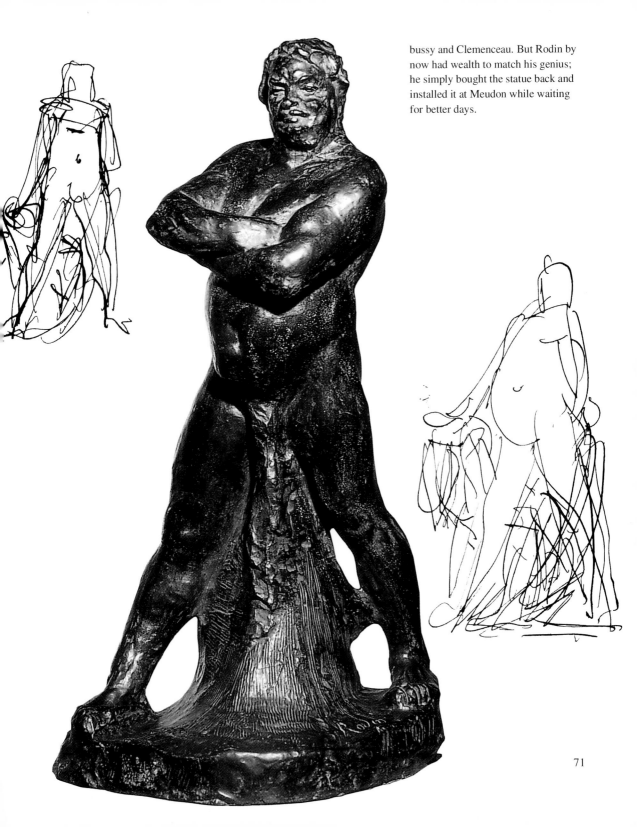

bussy and Clemenceau. But Rodin by now had wealth to match his genius; he simply bought the statue back and installed it at Meudon while waiting for better days.

71

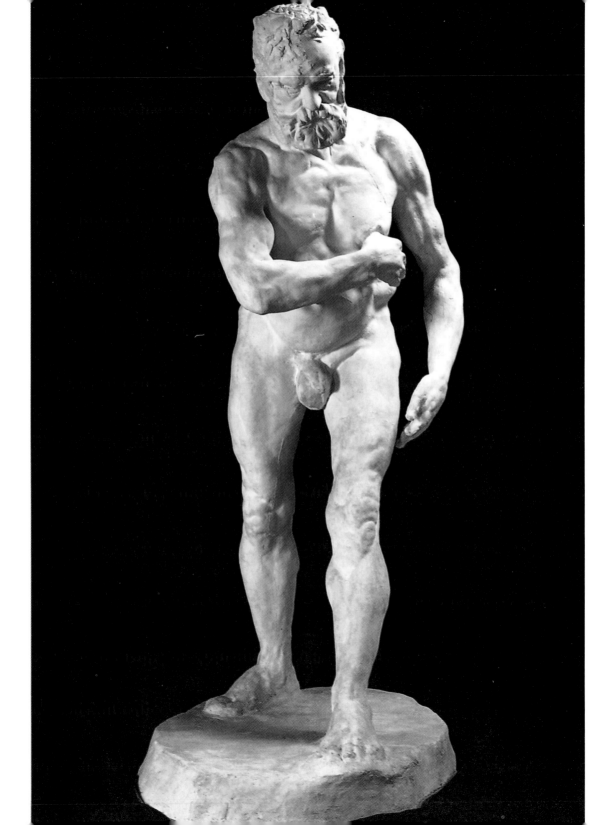

After the Balzac affair, the Hugo affair. The commission was similar in kind, and the criticism of the sculptor's proposal similarly virulent. Rodin had suggested a naked Victor Hugo, on the grounds that genius was not to be represented in a frock-coat. Other, more conventional projects were also rejected: the *Victor Hugo*

Victor Hugo deprived of Muses

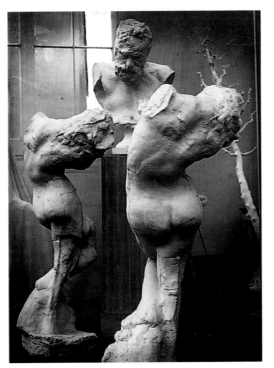

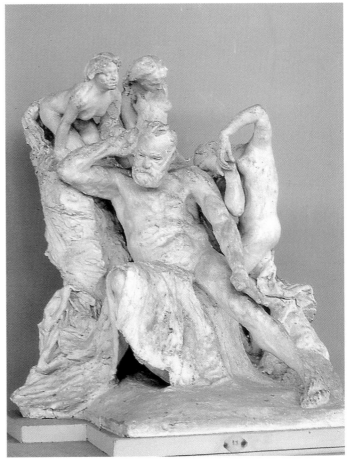

was described as a "rough-hewn, incoherent maquette". Rodin had met Victor Hugo and made numerous sketches, but the Muses with which he wished to surround him were deemed too erotic. The statue of the solitary, seated Victor Hugo was finally inaugurated in 1909 in the gardens of the Palais Royal, eighteen years after the commission.

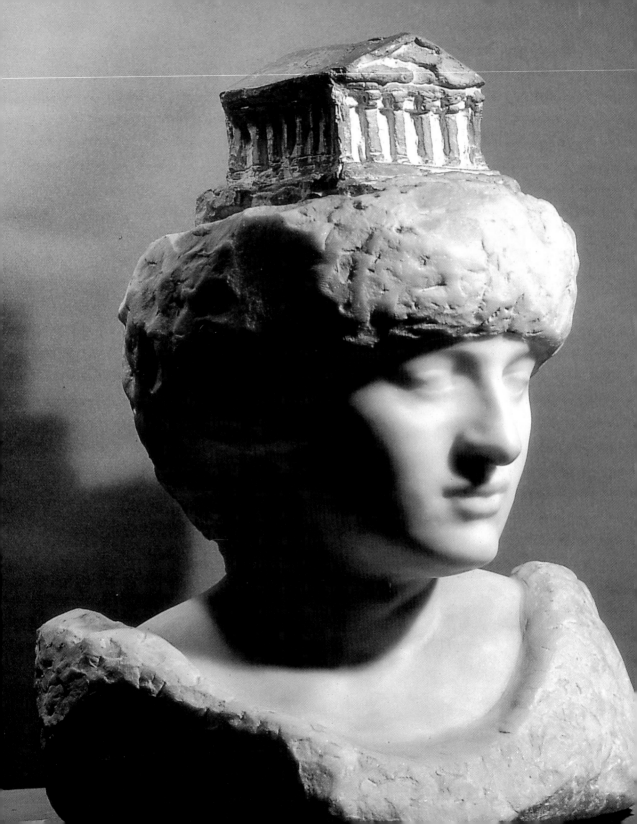

Unfinished Monuments

R odin, who was short-sighted, confined himself very largely to modelling the clay; he left the carving of the marble to his assistants. A number of heads were created in this way; two such are *Pallas at the Parthenon* (p. 74) and *The Tempest* (1898, p. 75), the one apparently dreaming of the wisdom of antiquity, the other possessing the epic tones of Shakespeare's play. These were often preliminary studies for monuments. Though Rodin left behind him a trail of scandal, his renown was such that commissions for monuments were lavished upon him. He normally accepted with enthusiasm, but his perfectionism and his restless spirit meant that they often remained unfinished.

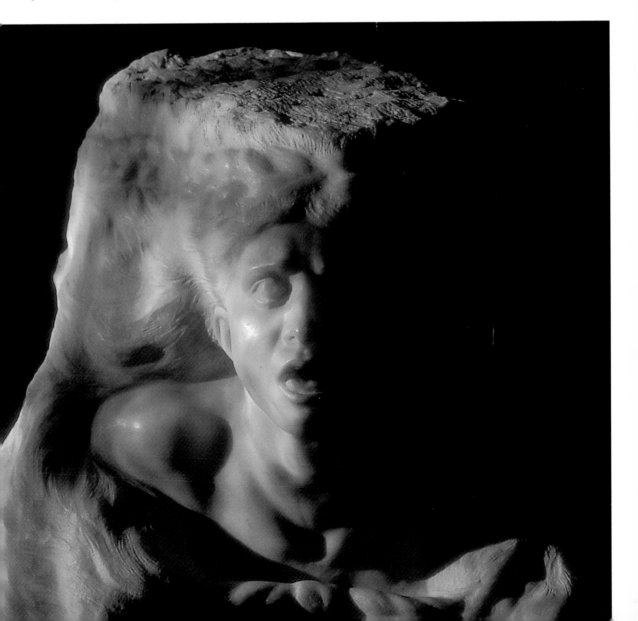

The Master's Hand

Towards the end of his life, the great delight of the "Sultan of Meudon" was to combine two sculptures to form a third. Was he thinking of the break-up of his liaison with Ca-

both of the *Despairing Adolescent* and the *Centauress* (p. 81). The left hand is clearly taken from studies for *The Burghers of Calais* which did not appear in the final version. Is it the powerful,

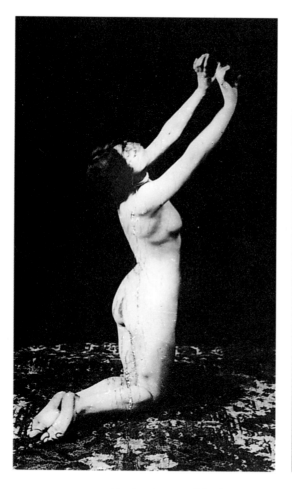

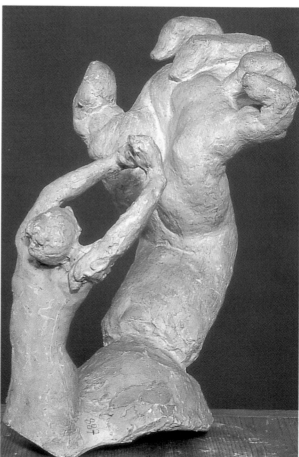

mille when he created the *Large Tensed Hand with Imploring Figure* (after 1890) in this way? He had a particular predilection for this pose which he had recorded in photographic form. The torso of the figure is reminiscent

brutal hand of the master raised against his pleading slave? Even specialist surgeons have been intrigued by the accuracy with which Rodin rendered the straining muscles, tendons and joints.

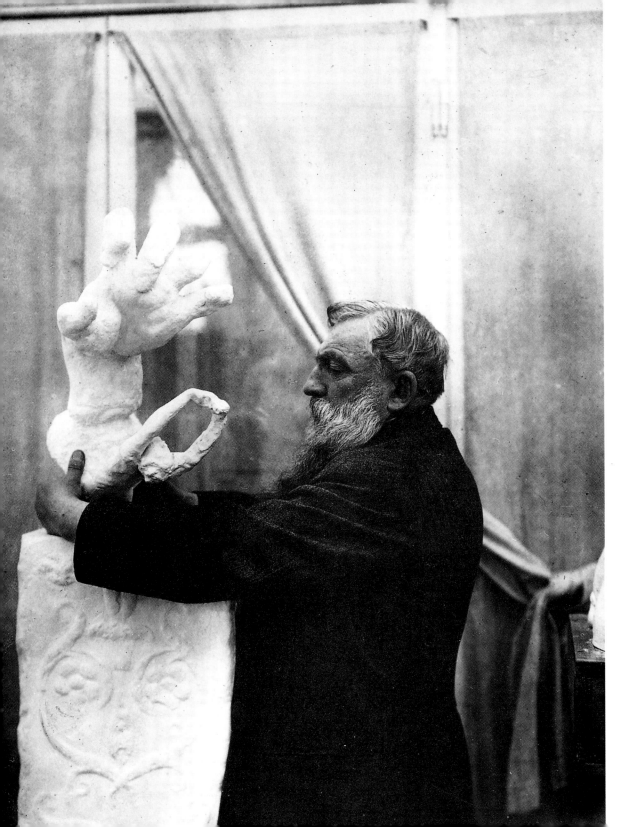

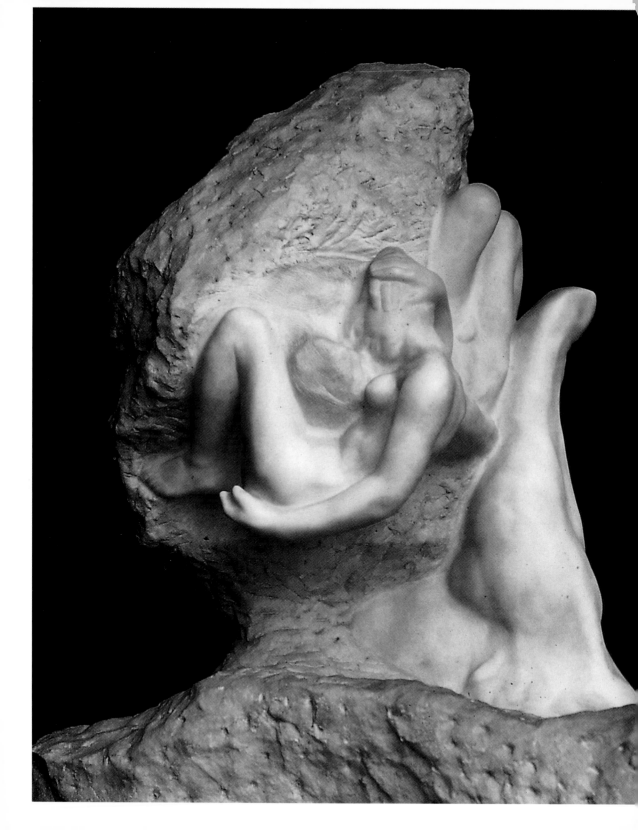

The Devil and the Good Lord

The same technique was used to compose *The Hand of God*, also called *Creation* (1902, p. 78), and *The Hand of the Devil* (1902, p. 79). All it required was to place a recumbent or contorted nude in one of the monumental hands which Rodin so brilliantly wrought from the unworked marble. Though accused of making excessive use of the unworked sur-face, Rodin was again far ahead of his time; he appealed to the imagination rather than to the roles of sculptural convention. Hands were something of a speciality for Rodin. Amongst the most beautiful are those of *The Cathedral* (1908, p. 9); in his view, it was hands thus joined in prayer which gave rise to the pointed arch.

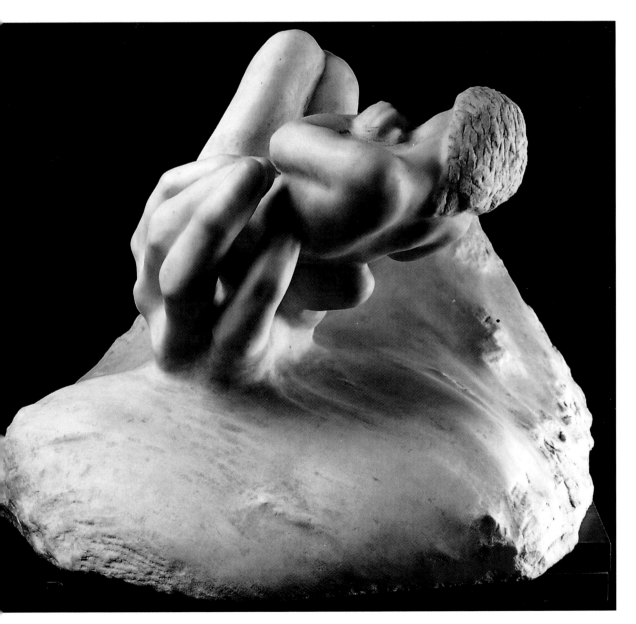

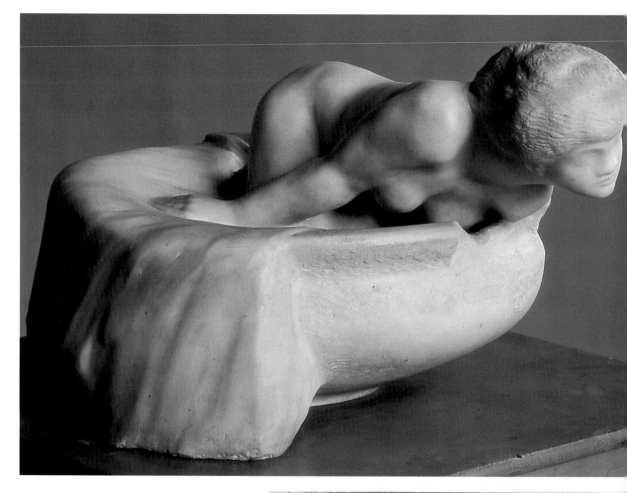

The Creature of Legend

Little Mermaid (1903, p. 80) is an-
other composite sculpture, made
by juxtaposing a nude and a classical
bowl. Degas, in his misogynous old
age, represented women from simi-
larly outlandish angles and in poses as
intimate as they were unconventional.
But as Monique Laurent notes "what,
in Degas' view, is 'the fat, vulgar

frog' is for Rodin the object of his passion, and he prefers to 'conjugate' the body without ever putting it in a position to be vulgar." Rodin was too much in love with Woman; for him she was "body and soul". She rep-resented the duality of spirit and instinct; she was, in a word, the *Centauress* (1901, p. 81), a creature of legend who fired his imagination.

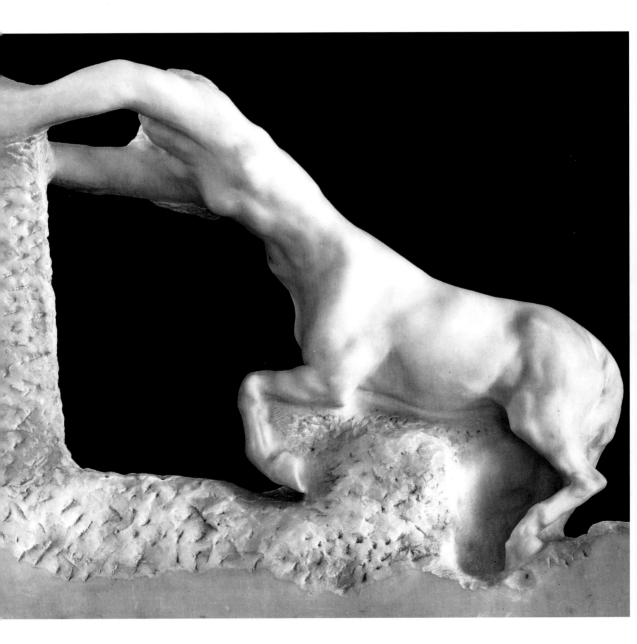

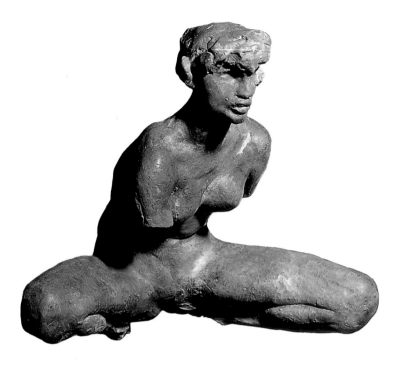

their god. The watercolours or wash drawings which were born of this hothouse atmosphere possess a freedom of invention and a sureness of touch that make of Rodin one of the masters of line-drawing of his time. Their vigorous eroticism betrays the tumultuously baroque world of Rodin's emotions. Some of these watercolours were used by the sculptor as studies for such sculptures as the *Large Crouching Woman Bathing* (1888, p. 82), or *Ecclesiastes* (1898, p. 82); the latter is an illustration of the famous Old Testament verse: "Vanitas vanitatum – vanity of vanities: everything is vanity…"

The Female Sex

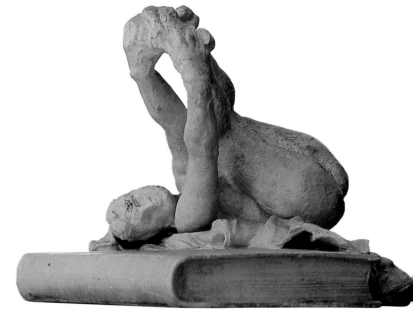

When not working on *The Kiss* (p. 67), which gained him the title of "the sculptor of the erotic" or *Iris, Messenger of the Gods* (p. 10), who spreads her thighs to reveal what Courbet called "The Origin of the World" and Rodin "The Eternal Tunnel", "the reincarnation of the God Pan" (as Isadora Duncan called him) devoted hour after hour to sketches of a feverish eroticism. His models were his favourites of the moment: rich foreigners, assistants, middle-aged or barely nubile admirers. All of these offered themselves enthusiastically to

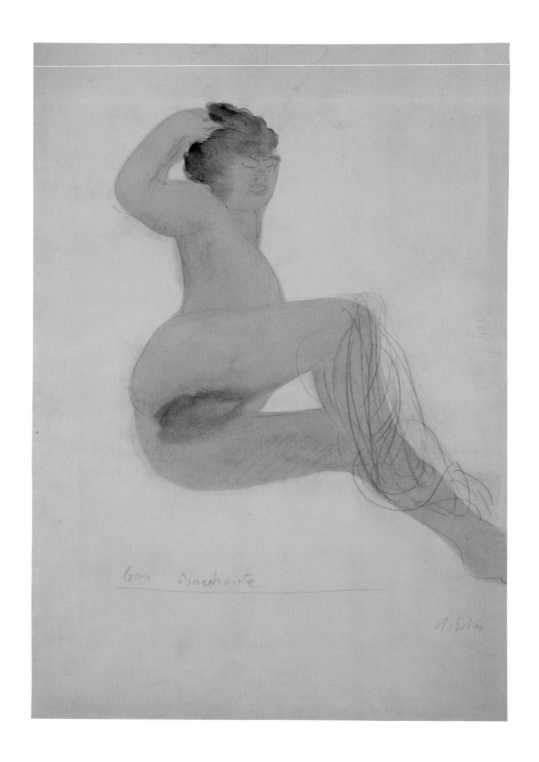

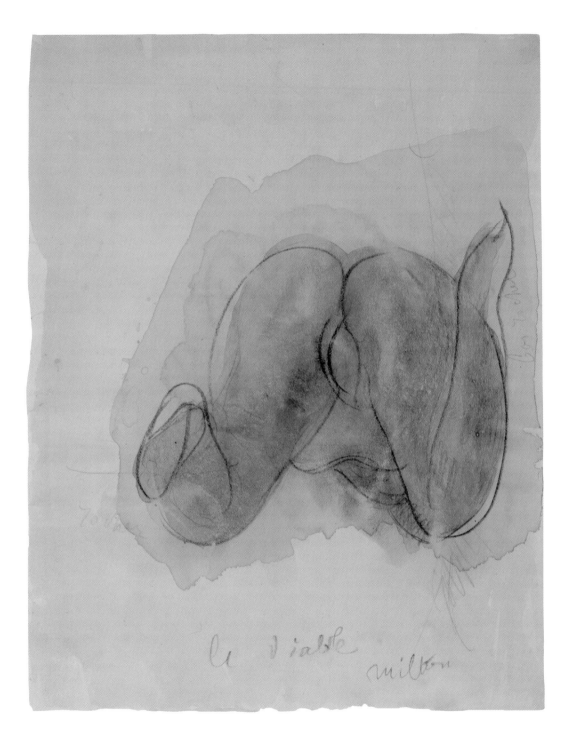

le diable
milton

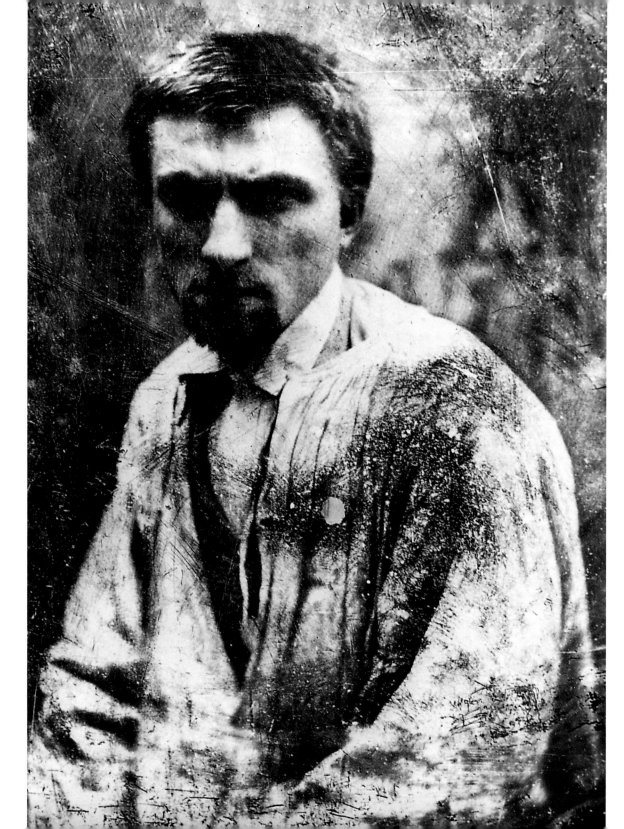

LIFE AND WORK

1840 Midday, 12 November, at 3 rue de l'Arbalète, Paris, birth of François-Auguste Rodin to Jean-Baptiste Rodin, 38, and Marie

Cheffer, 34.
1844 Rose Beuret is born in June.
1848 Rodin enters the school of the Frères de la Doctrine Chrétienne.
1850 Begins drawing after leaving school. Balzac dies.
1851 Boards with his uncle who runs a school in Beauvais.
1854 Enters the Petite Ecole. Pupil of Lecoq Le Boisbaudran. Friend of Dalou, Fantin-Latour and Legros.

Rodin in 1862
Rodin on his mother's knee in 1849
Rodin in 1864

1855 Discovers sculpture and begins modelling clay.
1857 Leaves the Petite Ecole. Charles Baudelaire publishes *Les Fleurs du Mal.*
1858 Three times fails the entrance examination of the Grande Ecole (Ecole des Beaux-Arts). Works as "statuary-mason" for various decorators and ornamentalists employed by the architect Haussmann in his reconstruction of Paris under Napoléon III.
1862 The death of his sister Maria at 25 prompts Rodin to enter the Pères du Très Saint Sacrement as a novice.
1863 Rodin leaves the order and returns to sculp-

ture on the advice of Father Eymard, who doubts Rodin's vocation. *Bust of Father Eymard.* Meets Carpeaux.
1864 Attends the course of the animal sculptor Barye at the Musée d'Histoire Naturelle. Various decorative jobs. Begins his collaboration with Carrier-Belleuse. Meets the pretty seamstress Rose Beuret. Camille Claudel is born. First studio rue Le Brun. Rodin sews buttons to help Rose in her work. *The Man with the Broken Nose* is refused by the Salon. *Bust of Jean-Baptiste Rodin.*
1865 With Dalou, takes part in the decoration of the Hôtel de la Païva.

Young Woman in Flowery Hat.
1866 18 January, Auguste-Eugène Beuret, son of Rodin and Rose, is born. *Bust of Madame Cruchet.*
1867 Continues to work as assistant to various ornamentalists. Sculpts *The Spring.* Baudelaire dies.
1869 *Mother and Child, Mignon.*
1870 Franco-Prussian War. Crushing defeat for France. Advent of the Third Republic. Rodin drafted into the 158th Regiment of the National Guard with the rank of Corporal.
1871 Invalided out due to short-sightedness, he leaves for Belgium thanks to Carrier-Bel-

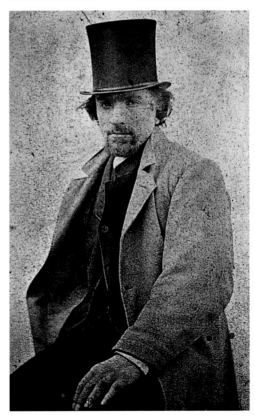

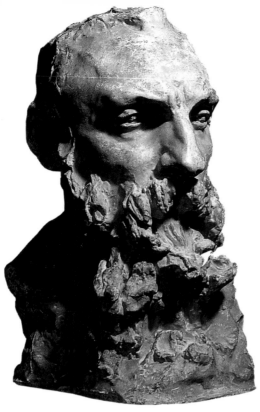

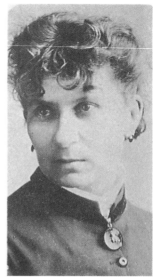

leuse, with whom he works on the decoration of the Bourse at Brussels. Paints landscapes in Belgium. Death of his mother.

1872 Rose joins Rodin in Brussels. End of the collaboration with Carrier-Belleuse, who returns to Paris. *Bust of Dr. Thiriard*.

1873 Enters partnership with Antoine-Joseph van Rasbourg in order to continue working in Belgium.

1874 Involved in various architectural motifs in Brussels: Boulevard Anspach, Palais des Académies, Conservatoire de Musique. In Antwerp: monument to Bourgmeister Loos. Term "Impressionism" coined and first group exhibition at Nadar's studio.

1875 Travels in Italy. Rodin visits Turin, Genoa, Florence, Rome and Naples. He begins *The Age of Bronze*

and *Suzon*. His friend Carrier-Belleuse is appointed Director of Art Work at the Sèvres Porcelain Manufactory.

1876 Stays in Italy: studies Michelangelo in Florence. Works on *The Age of Bronze*.

1877 Exhibits *The Age of Bronze* under the title *The Vanquished*, in commemoration of the 1870 war, at the Cercle Artistique of Brussels, then at the Paris Salon. Accusation of lifecasting, of which he is cleared by the testimony of his peers. Returns with Rose to set up home in Paris. *Walking Man*, a study for *Saint John the Baptist Preaching*.

1878 Involved in Palais du Trocadéro decoration. Rents a studio at 36 rue des Fourneaux. Presents a maquette for a monument commemorating the 1870 defence of Paris: *The Call to Arms*. Summer trip to Nice and Mar-

seille for ornamental work.

1879 Produces various pieces for Sèvres Porcelain Manufactory.

1880 Rehabilitation of Rodin: the *Saint John the Baptist Preaching* (larger-than-life-size to avoid further suspicion of chicanery) and *The Age of Bronze* are exhibited together at the Salon. The French state buys the latter for 2,200 francs. *The Gates of Hell* is commissioned, also by the French state; it will take Rodin nearly 40 years to complete. Studio at the Dépot de Marbres. *The Thinker, Limbo and Sirens*, and *Young Woman and Child*.

1881 Visits Legros in London who teaches him drypoint. He meets Henley and Stevenson in London. First drawings for the *Gates. The Three Shades. Saint John the Baptist* purchased by the French state.

1882 Begins a series of busts of the writers and artists among his friends.

1883 Meets Camille Claudel. *Bust of Victor Hugo.* Death of his father.

1884 The Calais Munici-

pality commissions *The Burghers of Calais. The Age of Bronze* is placed in the Jardins du Luxembourg.

1885 Works mainly on *The Burghers of Calais* and *The Gates of Hell. She Who Was "La Belle Héaulmière", Idyll, Young Mother, The Toilet of Venus, Danaïd, The Martyr*. First portrait of Camille: *Dawn*.

1886 Many representations of Camille and other figures incorporated in the *Gates: Thought, The Kiss…*

1887 Rodin made *chevalier* of the *Légion d'honneur*.

1888 Rodin rents the "Folie Neubourg" on the boulevard d'Italie as a studio for himself and Camille. Illustrations for Baudelaire's *Les Fleurs du Mal. Large Squatting Bather, Ascendancy, Sin*. The French state commissions *The Kiss*.

1889 Rodin-Monet exhibition at the Georges Petit Gallery. The *Victor Hugo Monument* commissioned. The Eiffel Tower is completed and triggers as great an uproar as Rodin's monuments.

1890 Travels in Touraine and Anjou with Camille.

Little Mermaid, The Bust of Rose, Iris, Messenger of the Gods, studies for *Victor Hugo*.
1891 Commission for the *Balzac Monument*. Travels in Touraine with Camille, following in the writer's footsteps. Studies for *Balzac*. Rejection of the *Victor Hugo* project.
1892 Officer of the Légion d'honneur. Inauguration of the *Claude Lorrain Monument* in Nancy. *The Farewell, The Convalescent, Orpheus Pleading for Eurydice's Return*. Finishes *Clothed Balzac*.
1893 Rodin succeeds Dalou as the President of the Sculpture Section of the Société Nationale des Beaux-Arts. Statue for the

Victor Hugo Monument, Orpheus and Eurydice.
Monet: *The Cathedrals*.
Munch: *The Scream*.
1894 Travels in the South of France. Meets Cézanne at Monet's house at Giverny. In Calais, studies the site of *The Burghers*. First attacks on the *Balzac*.
1895 Inauguration of *The Burghers of Calais*. Presi-

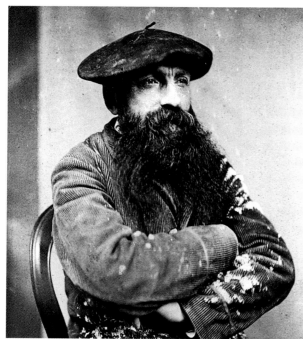

dent of the Puvis de Chavanne banquet. Resumption of his liaison with Camille.
1896 Exhibition at the Musée Rath in Geneva. Donates three sculptures to the museum.
1897 Moves to the Villa des Brillants at Meudon. Uproar over his *Balzac*. Octave Mirbeau publishes the first study of Rodin's drawings. Klimt founds the Vienna Secession.
1898 *Balzac* and *The Kiss* exhibited in the Galérie des Machines on the Champ-de-Mars. The Société des Gens de Lettres rejects *Balzac*. Violent press campaign against Rodin. Definitive break with Camille.
1899 Exhibition in Belgium and Holland. Prepares his own pavilion for the Paris World Fair. Commission for a *Monument to Puvis de Chavannes. Woman Undressing*.
1900 Opening of the Pavillon Rodin in the Place de l'Alma in Paris. It is a triumphant success: the 150 works exhibited win

him international renown. Rodin recovers his investment. Revelation of the *Erotic Drawings*. Freud: "The Interpretation of Dreams".
1901 Exhibits at the Venice Biennale and at the Third Berlin Secession.
1902 Travels to Prague for his exhibition there. Visits Czechoslovakia with Mucha. Stays in London for the delivery of the *St. John the Baptist Preaching* to the Kensington Museum. *The Hand of God, The Hand of the Devil*. Alexis Rudier becomes his official caster. Meets Rainer Maria Rilke and Isadora Duncan.
1903 Commandeur of the Légion d'honneur. Isadora Duncan dances naked for him in the Bois de Vélizy. Succeeds Whistler as the president of the International Association of Painters, Sculptors and Engravers. Begins the *Monument to Whistler*. Exhibitions in Berlin, London, Venice and New York. Publication of "Auguste Rodin" by Rilke and "Au-

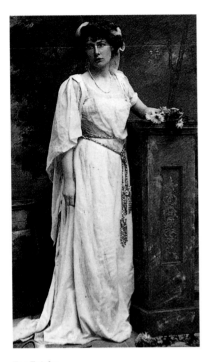

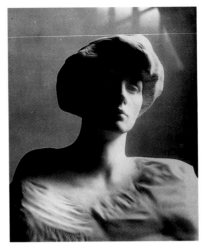

Eve Fairfax
Sem: Caricature in "L'Illustration", 1913

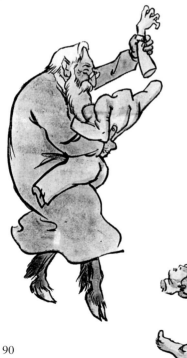

guste Rodin pris sur la vie"
by Judith Cladel.

1904 Liaison with the young English painter, Gwen John. In London also meets Claire Coudert, Duchesse de Choiseul, an American woman who acts as his impresario and expands his sales in the United States but who attempts to exclude others from Rodin's society and has a single purpose: to inherit his estate. Exhibition at the Metropolitan Museum. *Bust of Eve Fairfax*, *Lovers' Hands*, *France*.

1905 Rilke becomes Rodin's secretary. Rodin is delighted by the playing of harpsichordist Wanda Landowska, who performs for him at Meudon. Exhibits at the Autumn Salon for the first time. Klimt: *The Three Ages of Life* (inspired by Rodin's *She Who Was "La Belle Heaulmière"*.) The first Fauve exhibition creates uproar. Advent of "Die Brücke" group in Germany.

1906 *The Thinker* is placed in front of the Pantheon. Mme Segond-Weber of the Comédie Française declaims lines from Hugo as the famous statue, once compared to a "degrading pithecanthrope", is unveiled. Rodin

visits Spain with Rilke and the painter Zuloaga, going to Madrid, Toledo, Córdoba and Seville. Rilke is dismissed. *Drawings of Cambodian Dancers* inspired by the visits of the Cambodian Royal Ballet to Marseille and Paris.

1907 Made Doctor honoris causa of Oxford University. Reconciliation with Rilke. Picasso's preliminary sketches for *Les Demoiselles d'Avignon*, for which Cézanne and Rodin are the direct antecedents.

1908 The King of England, Edward VII, visits Rodin at Meudon. The Metropolitan Museum of Art in New York decides to acquire a large number of his works. Steichen photographs the *Balzac* by moonlight at Meudon. Rodin moves to the Hôtel Biron, to which Rilke had drawn his attention. *The Cathedral*, drawings of dance, *Duchesse de Choiseul*, *Mother and Child*.

1909 Inauguration of the *Victor Hugo Monument*. *The Secret*. The Ballets Russes come to Paris.

1910 Grand Officier of the Légion d'honneur. Study for *Dance*. Giacometti: *May Morning*. Munich: Group "Der Blaue Reiter". Larionov and Goncharova form the "Rayonnist" group.

1911 Short stay in London to choose the site for *The Burghers of Calais*. Bust of *Gustav Mahler*. *Composite works*. The French state buys the Hôtel Biron for the Ministère d'Instruction Publique et des Beaux-Arts.

1912 Trip to Italy. Break with the Duchesse de Choiseul, whom even Rodin can no longer tolerate. First attack of hemiplegia. Statue of *Nijinksy*.

1913 Camille confined to an asylum; Rodin sends money to pay for her treatment.

1914 First purchases by Mrs. Spreckel for her collec-

tion, now in the California Palace of the Legion of Honour in San Francisco. Spring trip to England for his exhibition at Grosvenor House. Travels for health reasons in the South of France. Early September, further stay in England, in the company of Rose and of Judith Cladel. Mid-November, short visit to Paris and departure for Italy with Rose and Loïe Fuller. *Hand Raised from the Tomb.* Germany declares war on France. Rodin develops a theoretical perspective on his sculptures and on art in general. His book, *The Cathedrals of France,* written with the aid of Charles Maurice, appears to great acclaim. Shortly afterwards, Rodin is traumatised by news of the shelling of Reims.

1915 Further stay in Italy to make a portrait bust of Pope

Helene von Nostitz
José Belon: Caricature from
"Le Charivari", 1899

— Ici l'on ne cultive que la pomme de terre. Pour les navets, s'adresser en face.

their solitary and derisory end in
the badly heated Meudon house;
they cannot afford enough coal.
14 February, Rose dies of pneu-
monia. 17 November at four in
the morning, Rodin dies. Funeral
24 November. Rodin lies by
Rose's side, under the statue of
The Thinker, at Meudon.

Benedict XV who had
been elected in succession
to Pius X the previous
year.
1916 A further attack of
hemiplegia in late March.
10 July, a stroke. Septem-
ber: Rodin's donation and
bequest to the French
state. This disposes of the
many inheritance-seeking
women by whom the
ageing master is sur-
rounded.
1917 Rodin is persuaded
by Loïe Fuller to marry
Rose Beuret, which he
does at Meudon on 29
January. Now that he has
made the state his heir, no-
one is interested in him.
The two old people meet

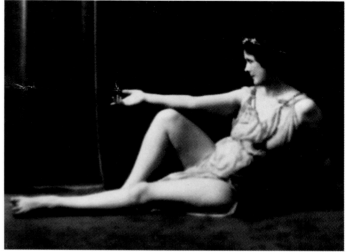

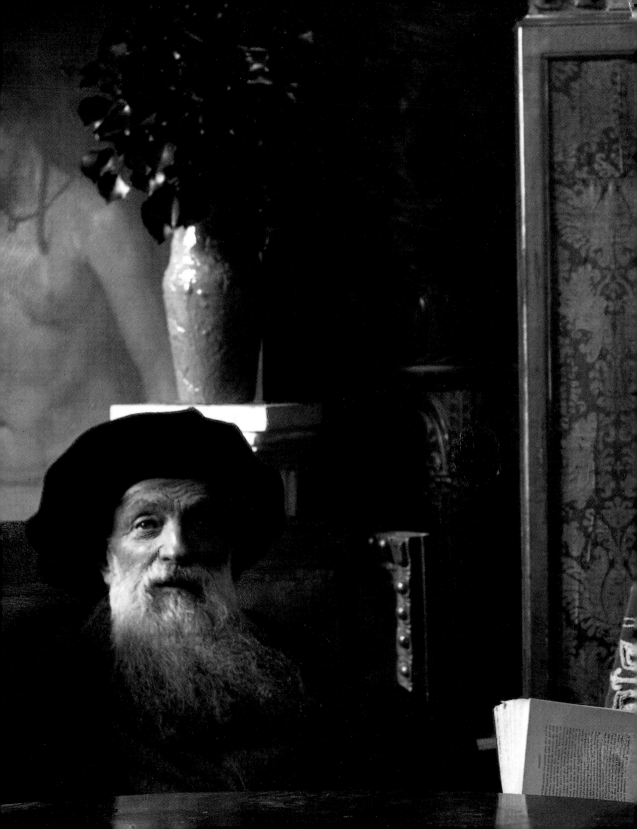

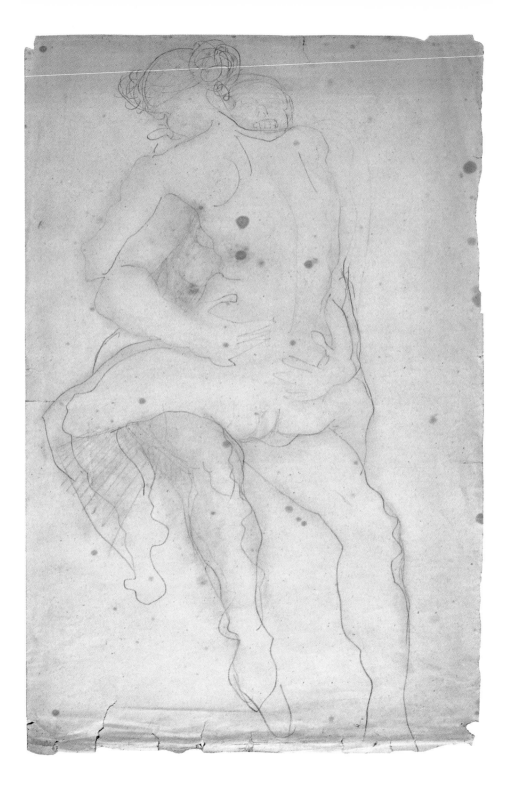

Index of Works

SELECT BIBLIOGRAPHY

Auguste Rodin, *L'Art*, ed. by Paul Gesell, Bernard Grasset: Paris, 1911.

Auguste Rodin, *Les Cathédrales de France*, Librairie Armand Colin: Paris, 1914.

Judith Cladel, *Le sculpteur Auguste Rodin pris sur la vie*, La Plume: Paris, 1903.

R. M. Rilke, *Auguste Rodin*, J. Bard: Berlin, 1903.

Robert Descharnes/Jean-François Chabrun, *Auguste Rodin*, Edita: Geneva, 1967.

Yvon Taillandier, *Rodin*, Flammarion: Paris, 1980.

Monique Laurent, *Rodin*, Chêne-Hachette: Paris, 1988.

Hélène Pinet, *Rodin, les mains du génie*, Gallimard: Paris, 1988.

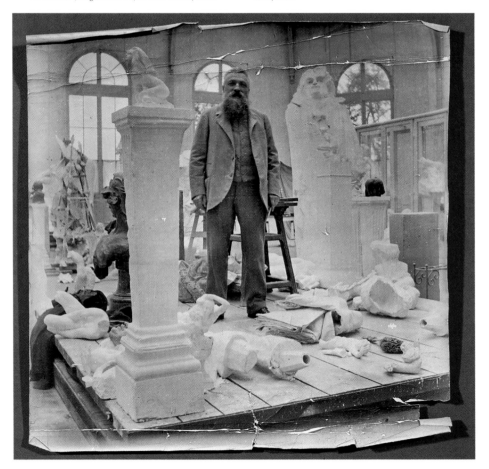

The publisher would like to thank the photographers, museums and owners for permission to reproduce the documents on the following pages:

© Descharnes & Descharnes: 6, 9, 14, 15, 16, 17, 19, 20, 21, 26, 27, 30, 31, 32, 32-33, 33, 34, 35 t., 35 b., 36 t., 36 b., 37 l., 37 r., 38, 39, 40, 41, 44 t., 44 b., 45, 46, 47, 48, 49, 50-51, 60 l., 64 l., 64 r., 66, 68 l., 68 r., 69, 70, 71 l., 73 l., 73 b. r., 75, 76 l., 76 r., 78, 80 t., 82 t., 82 b., 86, 87 t., 87 b., 88 l., 89 b., 89 c., 90 b. l., 90 b. r., 91 b., 93, 96.

© Musée Rodin: 18 l., 18 r., 19 r., 21, 62, 63 l., 63 r., 73 t., 74, 77, 88, 89 r., 90 t. l., 90 t. c., 90 t. r., 91 t. l., 92 t. l., 92 t. r., 92 b.

© Musée Rodin, © Photo Bruno Jarret/ADAGP: 10, 12-13, 24-25 t., 25, 42, 43, 52, 53, 54, 55, 56, 61, 65, 67, 71 r., 79, 81, 91 t. r.

© Musée Rodin, © Photo Adam Rzepka/ADAGP: 26 r., 28-29, 58, 59.

© Musée Rodin, © Photo Béatrice Hatala: 72.

All rights reserved.

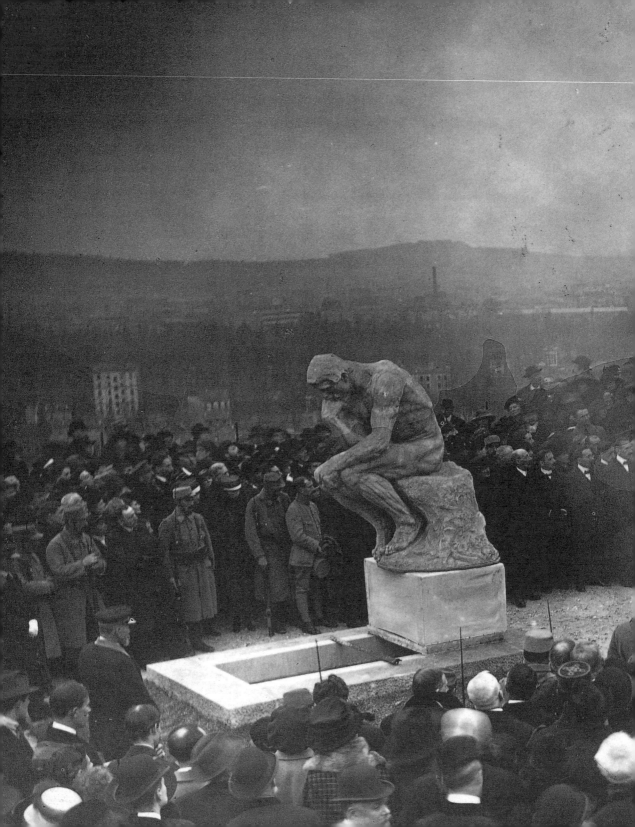